THE FALLS

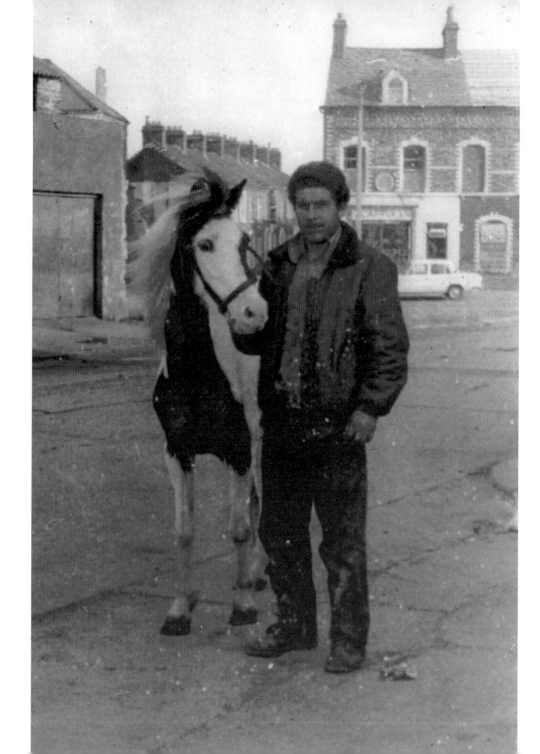

Frankie Slane, a jack
of all trades, at the
junction of Slate Street
and Cullingtree Road

THE FALLS

THE PEOPLE, THE COMMUNITY, THE MEMORIES

VINCENT DARGAN

BLACKSTAFF PRESS

To my family: my wife Marie, my daughter
Marie Louise and my son Paul, and also my
late mum and dad, Kathleen and Timothy

First published in 2013 by Blackstaff Press
4D Weavers Court
Linfield Road
Belfast BT12 5GH

With the assistance of
The Arts Council of Northern Ireland

Supported by
The National Lottery®
through the Arts Council of Northern Ireland

Vincent Dargan has asserted his right under the Copyright, Designs and
Patents Act 1988 to be identified as the author of this work.

Designed by Lisa Dynan
Printed and bound by GraphyCEMS

A CIP catalogue record for this book is available from the British Library

ISBN 978 0 85640 916 5

www.blackstaffpress.com
www.belfastimages.org

CONTENTS

INTRODUCTION

I was born in 1943 in Slate Street in an area of the Falls called the Lower Wack. My family had been in the area for three generations, and I lived there until my mid-twenties.

In 1965 I acquired my first book on photography, called *The Right Way To Use a Camera* by Laurence Mallory. It was very informative and even gave instructions on how to create your own dark room at home, which I set about doing almost immediately at our house on Slate Street.

I next had to get myself a camera but, with little money, I found this hard to do. Until one day I came across a camera shop in Ann Street called The Amateur's Nook. It was owned by Mr Hodes, a helpful and kindly gentleman, with a vast knowledge of cameras and film processing, which he freely imparted to his customers.

I explained my financial situation and he agreed to let me have my first Single Lens Reflex (SLR) Zenith B camera on tick. I was now on my way as an amateur photographer. From the very first time I successfully developed a black and white 35mm film and processed my first enlarged print in my dark room, I was hooked.

In the 1960s, a camera was a novelty, and not many people had one. The word soon spread on the community grapevine that I was available to take family portraits in people's homes. These became a bit of a craze and, through these contacts, I was booked to do local weddings, First

Communion portraits and even photographs for local newspapers. I was also a street photographer, taking photographs of the ordinary people of the community going about their everyday business – the tradesmen, the neighbours, the celebrations and so on. I ended up with an enormous collection of photographs of the Falls Road and its people in the late 1960s and early 1970s.

As I was choosing the photographs for this book, each one brought back many memories of the special people that I had the pleasure of knowing during the years I lived in the area. Unemployment was rife and poverty was widespread, but there was a true sense of community – visitors were always welcome, doors were always open, and neighbours helped each other, especially in times of need.

These photographs capture a time of great change. The combination of civil unrest, the area's location in the heart of West Belfast, and the extensive housing redevelopment eventually led to the disappearance of the close-knit village communities that I grew up in.

When I recently visited the area where I'd grown up, I felt like a stranger in my own city. It felt as though all of those values that were so important at the time I lived there had been lost forever. I hope that this book will help to ensure that those communities are never forgotten.

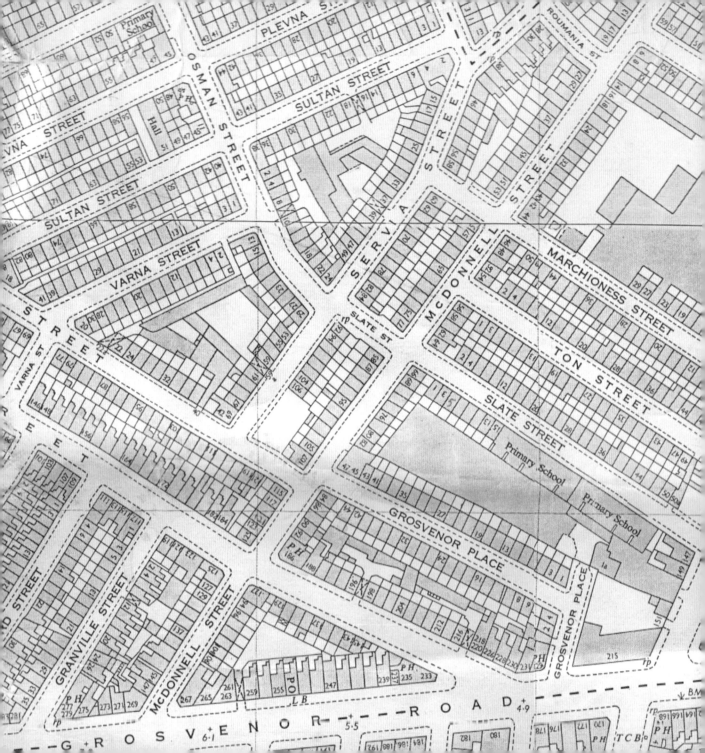

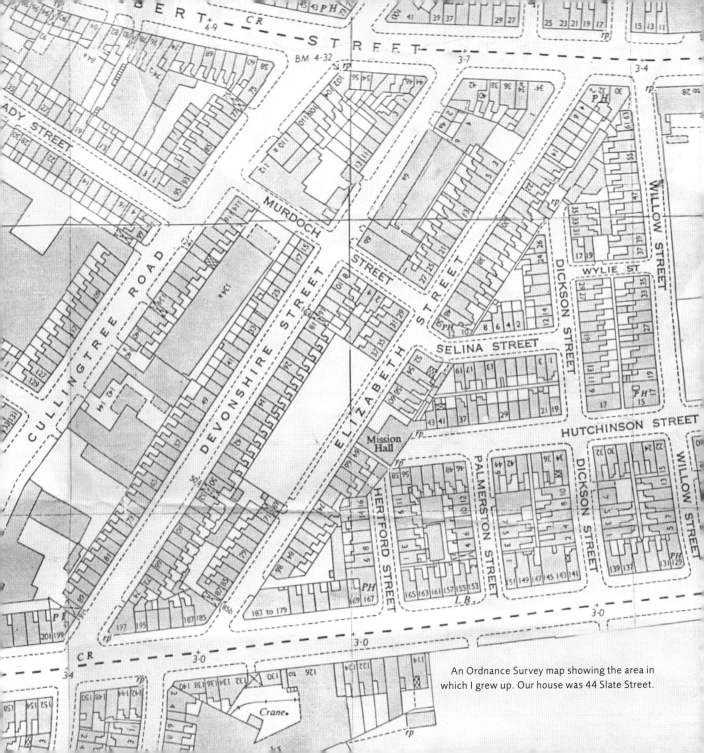

An Ordnance Survey map showing the area in which I grew up. Our house was 44 Slate Street.

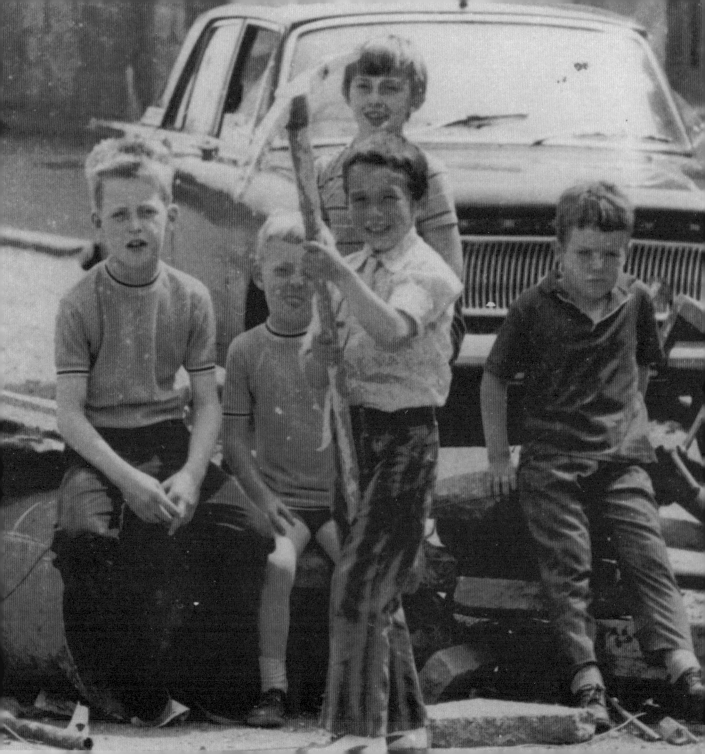

CHILDHOOD

Growing up in the little streets off the Falls Road in West Belfast during the 1950s and '60s was, to say the least, a Dickensian experience. To quote the Divis flats Immaculata Amateur Boxing Club (ABC) motto, 'Only the strong survive[d]'. We did not have Xboxes or Gameboys or Wiis; and the few neighbours who had black and white televisions regularly had a host of neighbours' kids in their two-up, two-down houses to watch the latest Westerns. There was widespread poverty and poor housing but the children had great freedom – playing football, marleys (marbles) and hopscotch in the streets, in a community where neighbours' doors were always open.

Children playing on the remnants of a barricade in Albert Street in the Lower Wack

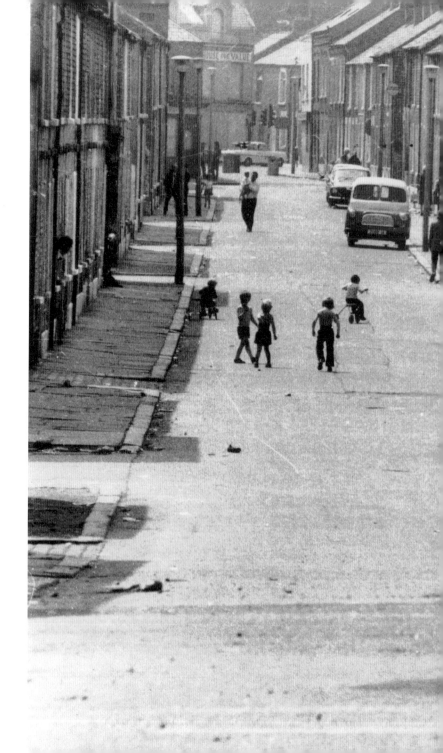

The children in McDonnell Street are able to play in the middle of the road as there is so little traffic. Close by, neighbours are sitting at their doors, enjoying the summer sun. At the far end of the street, adjacent to Sloan's Grocery Shop and Sloan's Drapers, is a makeshift barricade.

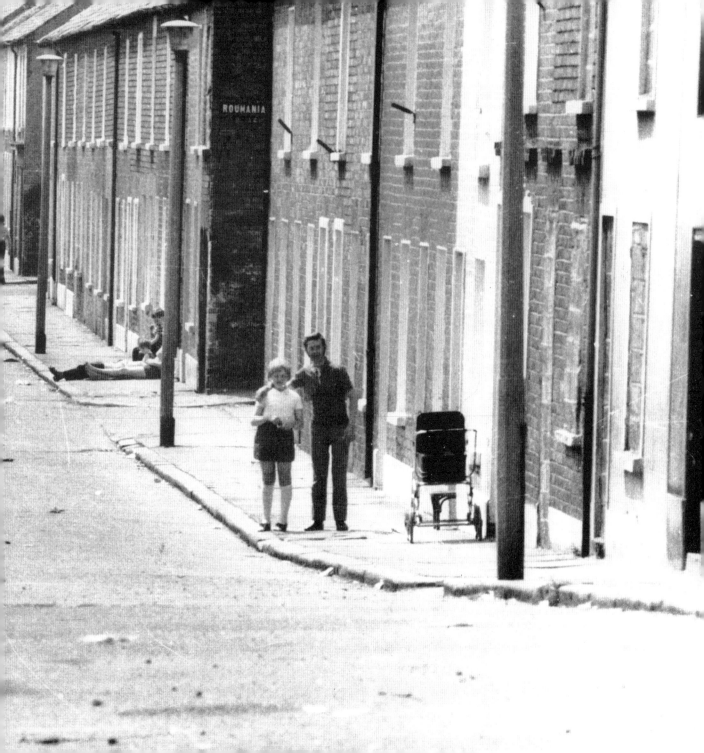

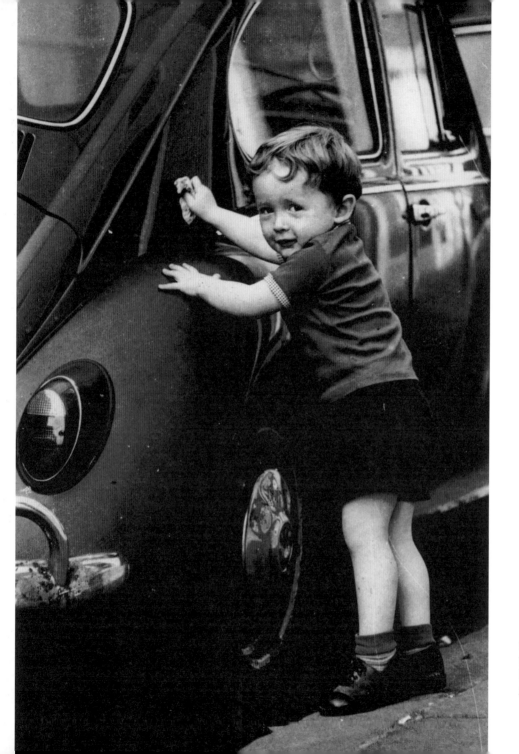

Washing my dad's car.
When I grow up, I will
have my own carwash and
garage in Slate Street.

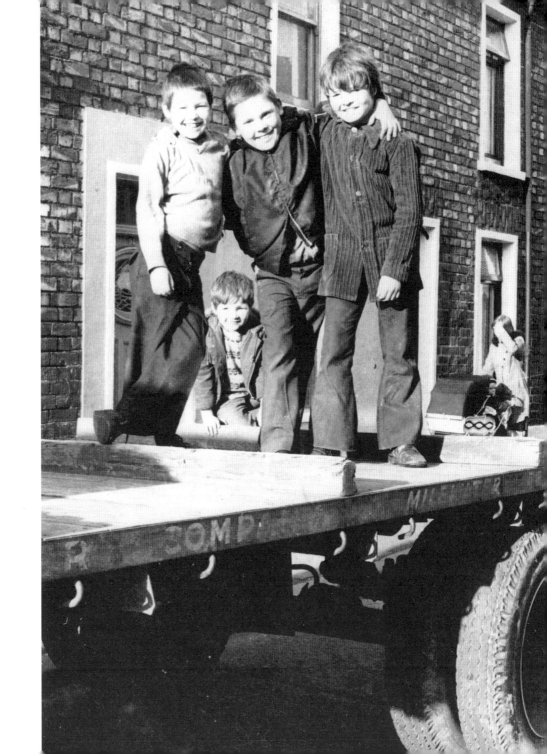

Is there room for one more? Haven't we all done it – hopped on the back of lorries and carts? Here four lorry-hoppers are playing on the back of a stationary lorry in McDonnell Street, owned by loader, Mr Christie Meek.

The old RUC barracks at the junction of Murdoch Street and Cullingtree Road. Back in those days, the peelers would walk about in pairs and if they saw you and your team playing handball or football against a neighbour's gable wall, you had to be quick off the mark to avoid being taken by your shirt collar to the copshop and fined between five and fifteen shillings. The worst part was having to go home and ask your cash-strapped family to pay your fine.

A babysitter in Lady Street, Lower Wack. This was a common sight in streets all over the Falls where children took on housekeeping responsibilities from an early age. This baby is in a high pram, typical of the time.

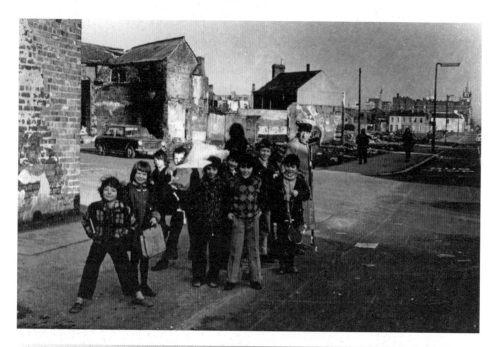

OPPOSITE
A group of girls from St Joseph's School in Slate Street wait for the school bell to ring as they chat to the school patrolman in the waste ground where Benny Strong's pub used to stand, at the junction of Slate Street and Cullingtree Road. This area of ground was left derelict for a long time before the authorities decided to build a play area there for the school children. The play area on the roof of the school was rarely used.

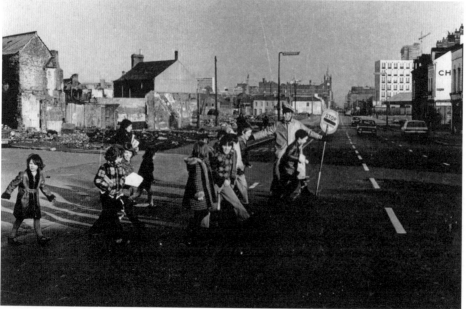

A group of boisterous pupils from St Joseph's first pose for a photo at the junction of the Cullingtree and Grosvenor Roads, and are then helped to cross safely by local patrolman, Jimmy Connors. The main road, which reaches right down to the British Telecom building (on the far right of the bottom photograph), is so much clearer than it would be now.

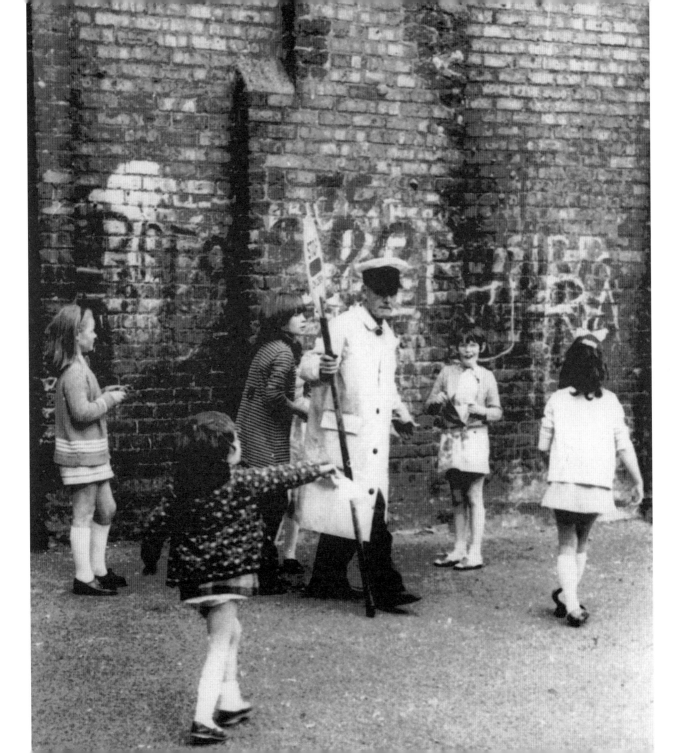

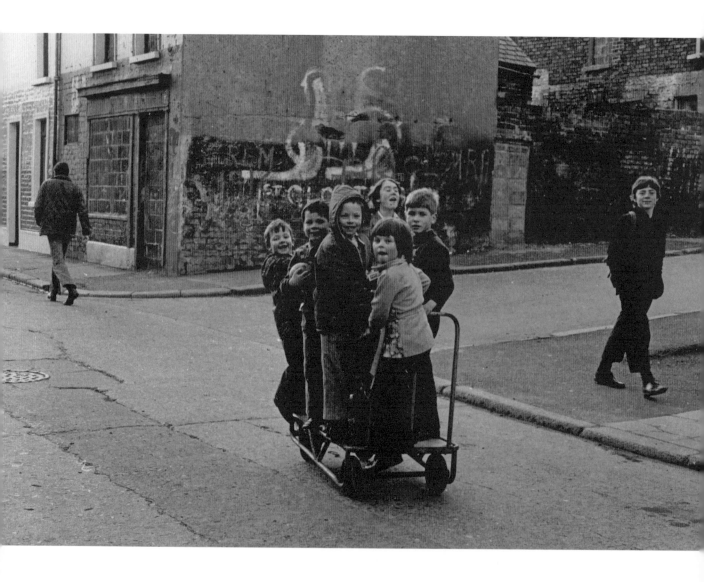

Some children prefer to walk to school. Others, more adventurous, hitch a downhill ride on an old discarded trolley in McDonnell Street. The trolley boys are Gerald Caudwell, Steven Gilroy, Anthony Dunlop, young Sloan and young Larkin. Every generation of kids improvises when they can't afford their own toys, and the kids on the Falls were no exception. As well as making the most of old trolleys, they also built guiders, using a plank, some pram wheels and some ball bearings. The best thing of all was to have two or more guiders and race them noisily up and down the streets, much to the annoyance of the adults. Is it any wonder that most of these guiders ended up over the wall of a disused back entry?

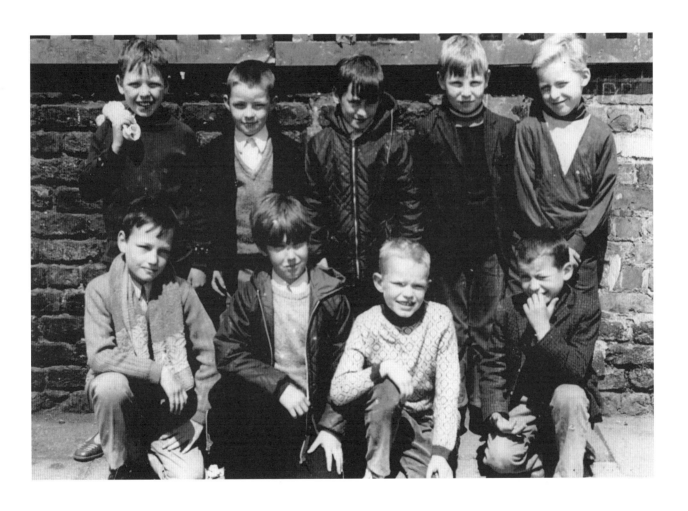

Kids from the Lower Wack take time out to pose for a photograph at the junction of the Grosvenor and Cullingtree Roads.

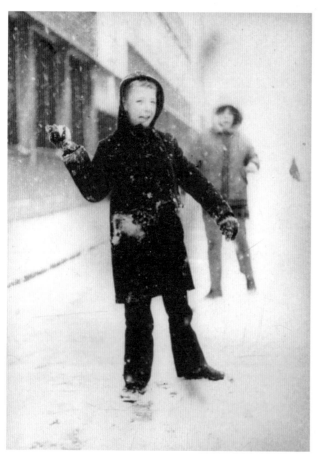

Playing in the snow in Slate Street in the 1970s

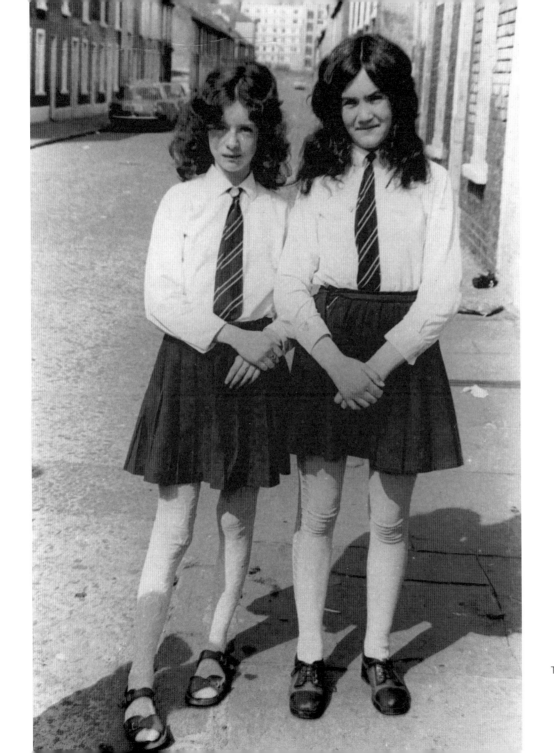

St Louise's
Comprehensive
College girls
Ann Conlon and
Mary Duffin pose
in McDonnell Street.
The Divis flats complex
is in the background.

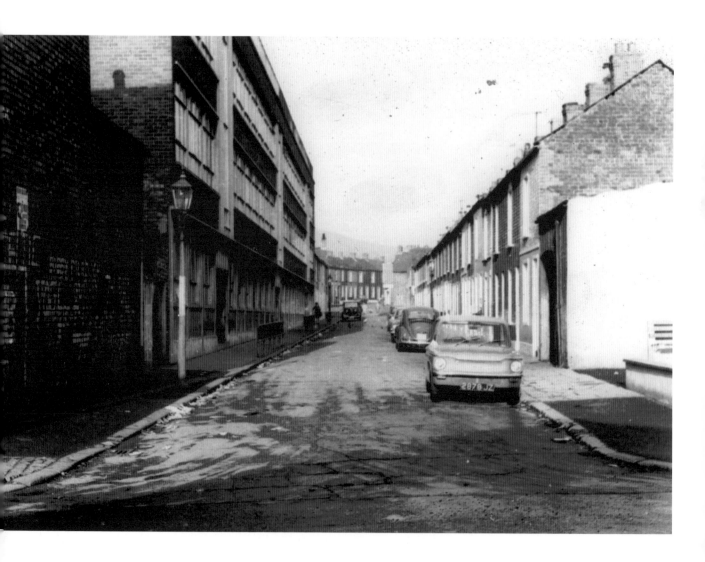

On the left you can see St Joseph's school with its rooftop playground; on the right are the traditional terraced houses, which were soon demolished. In the background is the Slate Street opening leading to Osman Street.

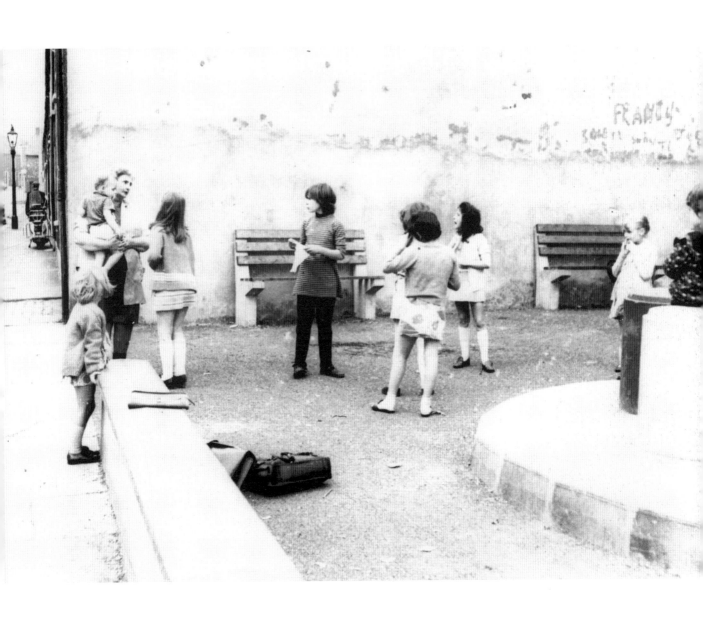

A group of girls playing in 'Benny Strong's ground' after its renovation

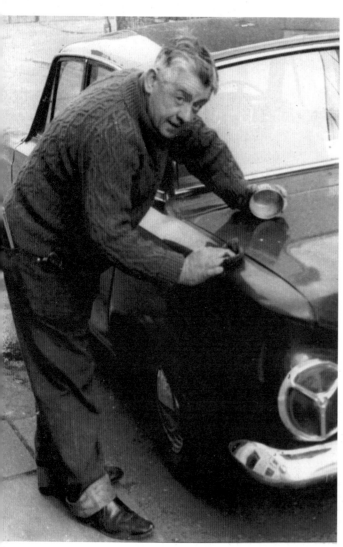
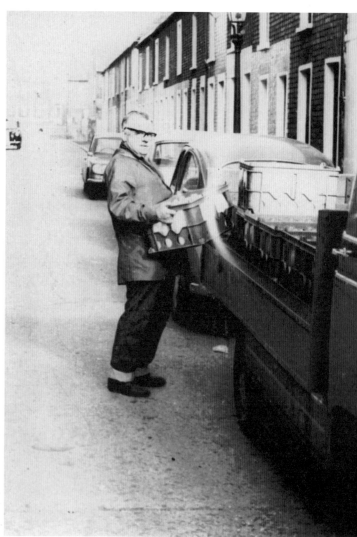

Pat (Paddy) McVeigh, school caretaker and milkman for Brown's Dairies

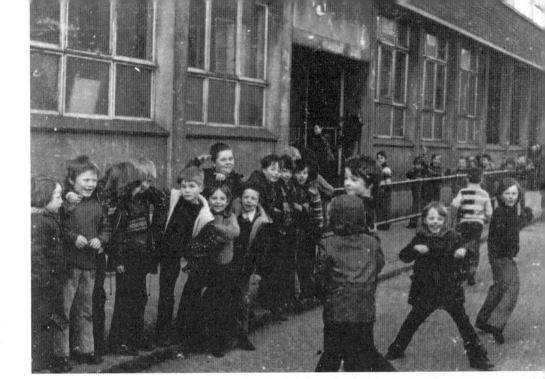

These children are messing around, having a bit of noisy fun before the whistle blows for assembly at St Joseph's School, Slate Street.

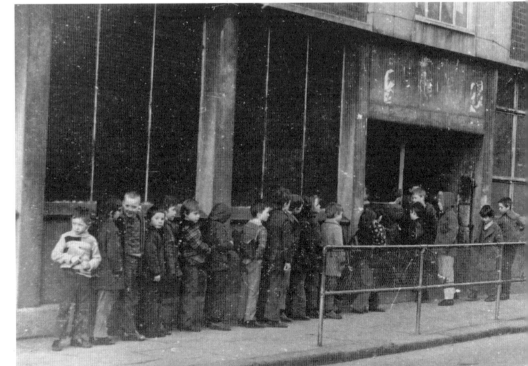

But it's wonderful what a few bursts of a scout's whistle can do when blown by the headmaster, Hugh Murtagh. The children soon line up in an orderly fashion.

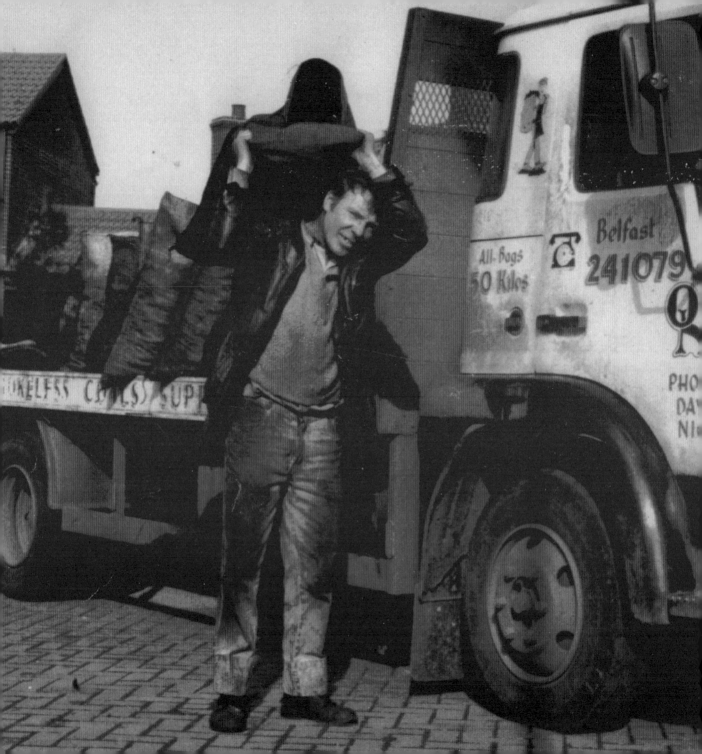

TRADES

Within the three main arteries – Grosvenor Road, Cullingtree Road and Albert Street – leading to the Lower Wack and the Pound Loney, there were at least twenty-four public houses. Weekdays were often very quiet but Fridays made up for that, with all the tradesmen meeting in their favourite pub, to collect the money they would earn for doing homers (extra jobs carried out in their own time) from the contractors. Friday was always a happy time in the community – perhaps with that extra money a Sunday-best suit could be retrieved from the pawnbroker to wear at the weekend, or the kids would get some pocket money to spend on treats from Eddie's in Lady Street, Crossey's in the Pound Loney or Ann's in Barrack Street. Even the local cats got a treat – fish from the fishmonger who went round the streets, calling 'Herrins, Aley Ardglass Herrins'.

The coalmen – or angels with dirty faces – were a familiar sight. Before the coal could be delivered the coalman had to go to the coal quay in Belfast to fill the bags (each one weighing 50 kilos / 8 stone) and then load them on to the back of his lorry. The heavy bags had to be carried on his back through the little two-up, two-down houses to the coal bunker in the backyard. On Fridays he collected the money from his customers. If they didn't have it, he would just say, 'it'll do again'.

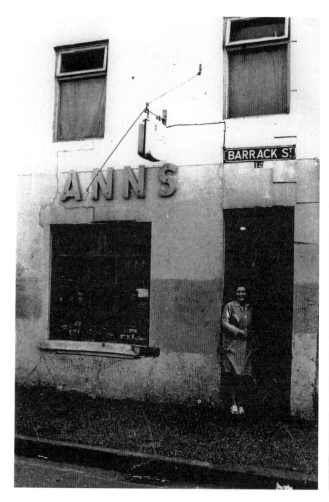

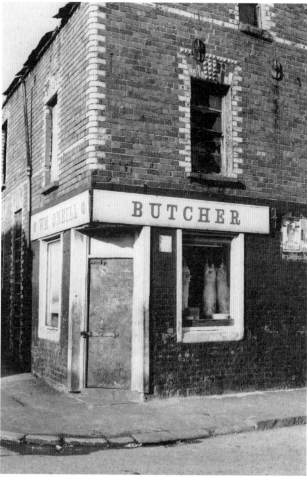

Ann's Shop at the junction of Barrack Street and
Durham Street. At almost every corner of every
street in and around the Falls you would find a little
shop. They were known locally as huckster shops.

Raymond O'Neill, the butcher, still serving his
customers during modernisation. His premises were
at the junction of Osman Street and Servia Street.
In 1968 the whole of the Falls Road neighbourhood
had a vesting order put on it to enable the council,
after years of neglect, to proceed with the housing
modernisation program.

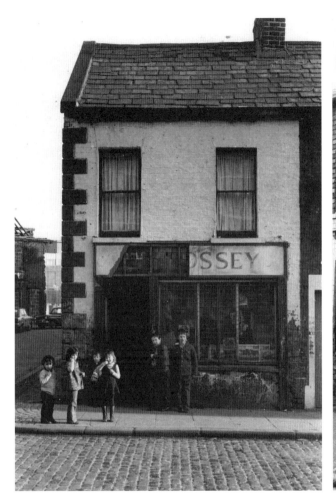

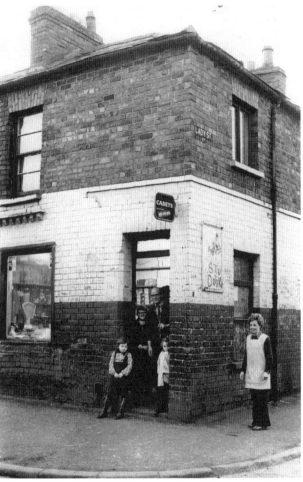

Edward Crossey's huckster greengrocers shop at the junction of Cullingtree Road and Brook Street in the Pound Loney, with the familiar sight of the old cobblestone road and small children playing in the street.

Eddie's corner shop at the junction of Lady Street and Cullingtree Road. The owner, Eddie, is standing at the door.

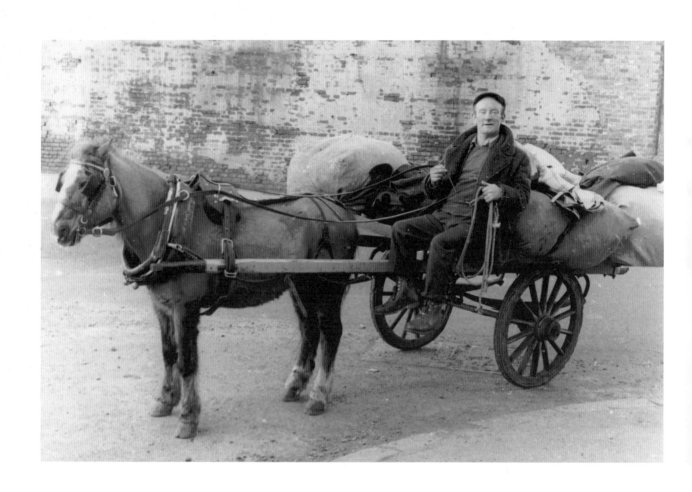

Ragman and market dealer Paddy Darling at
Grosvenor Place, off the Grosvenor Road, heading
for May's Market.

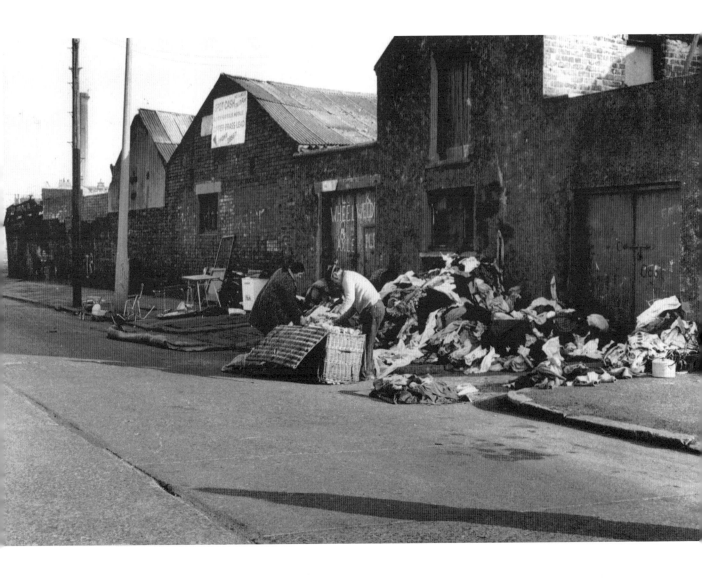

The workers are sorting the cotton from the wool in Cullingtree Road, before the rags go to market to be sold to the stallholders.

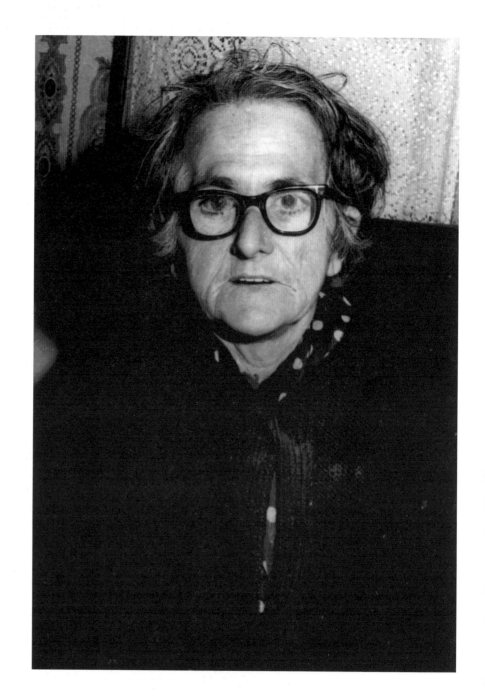

Josephine McAvoy and my wife
Marie Magee at the junction of
McDonnell Street and Slate Street

The late Miss Josephine McAvoy
was the local tailoress and market
dealer – give her an old overcoat
and she could make a boy's suit.
She was known locally as The Twin.
I photographed Josephine in her
house, 1 Slate Street.

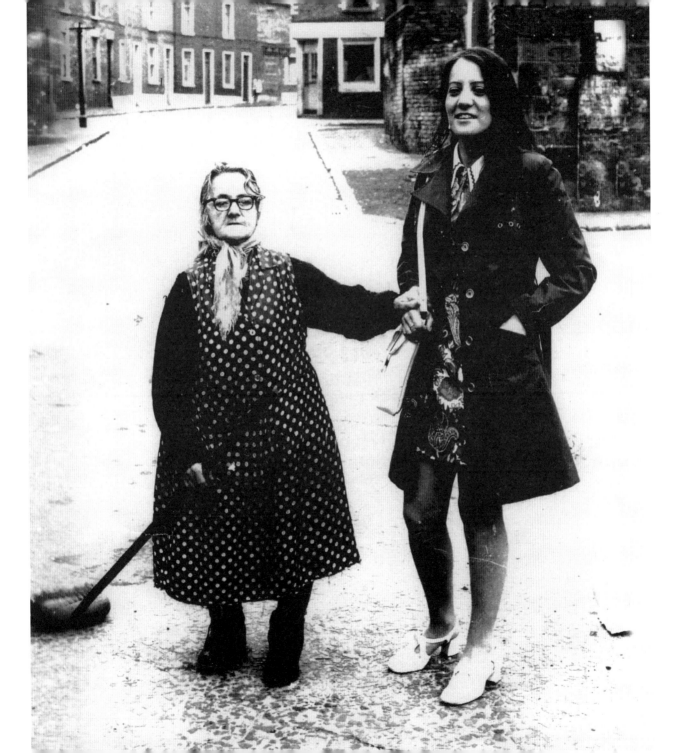

The local milkman was Eddie Brown of Brown's Dairies, a family-run business based in Slate Street. The sounds of Eddie making his deliveries at five o'clock in the morning were reassuring: you'd hear the steady rumble of the diesel lorry, the rattle of the metal crates as he arranged the milk bottles at the back of the lorry, and the clink of the full bottles of milk and orange juice as he left the customers' order on their windowsill.

Christy Brown (Eddie's youngest son)

Eddie Brown

Paddy Brown (Eddie's middle son)

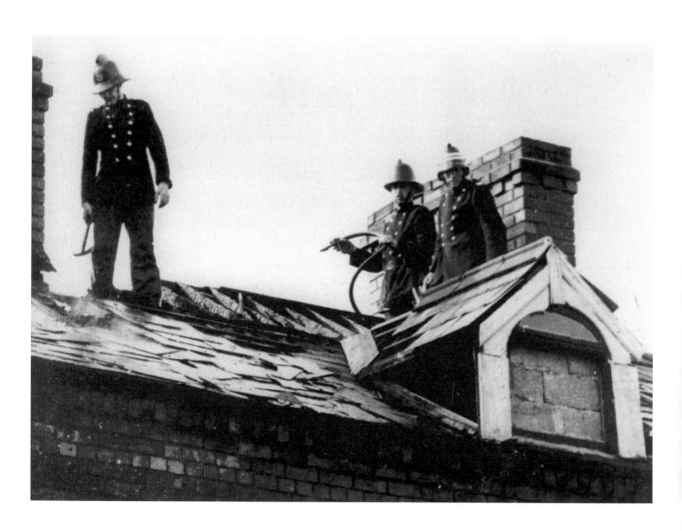

Three firemen extinguish a fire in Mrs McGivern's
grocery shop, Cullingtree Road.

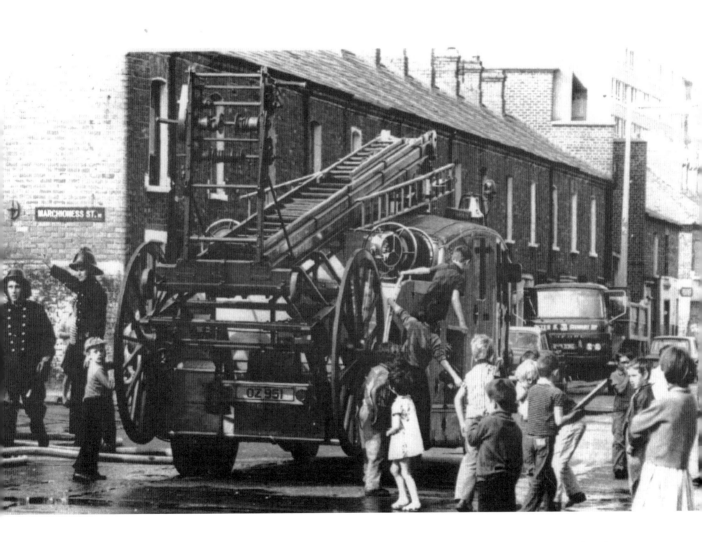

Local children gather around the fire engine.

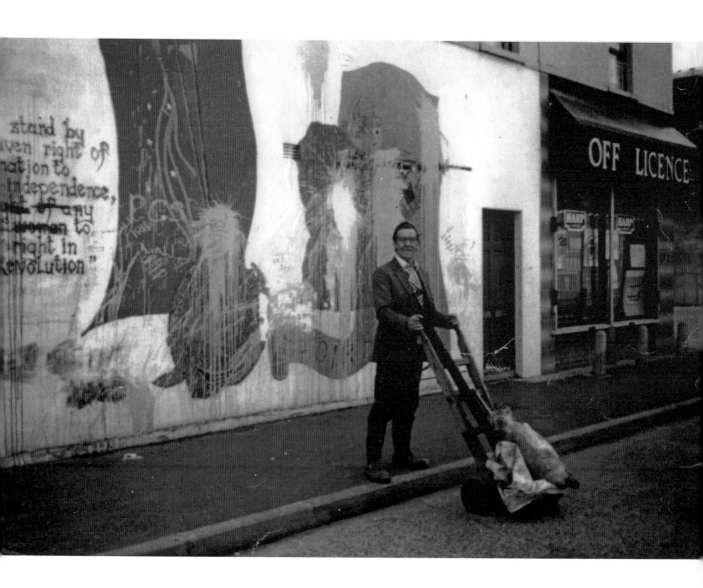

Geordie Finn, scrap metal dealer, photographed
in the Clonard area of the Falls

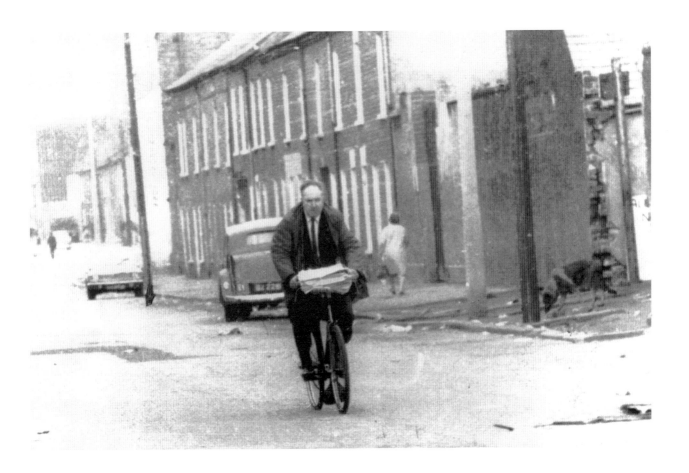

The *Tele* man cycling along Cullingtree Road with his papers on the handlebars of his bike. Jimmy Smith, a newsagent in Raglan Street, also had a group of local lads out on the streets selling papers for him. Each had his own patch around the Falls, and anyone who tried to sell on someone else's patch would be at risk of getting a 'dig in the bake'. I loved selling the papers, especially when I wanted a free ride on the old Corporation red buses. It was well established that, in return for a paper, the conductor would let you travel from terminus to terminus, up and down the Falls Road, as often as you liked.

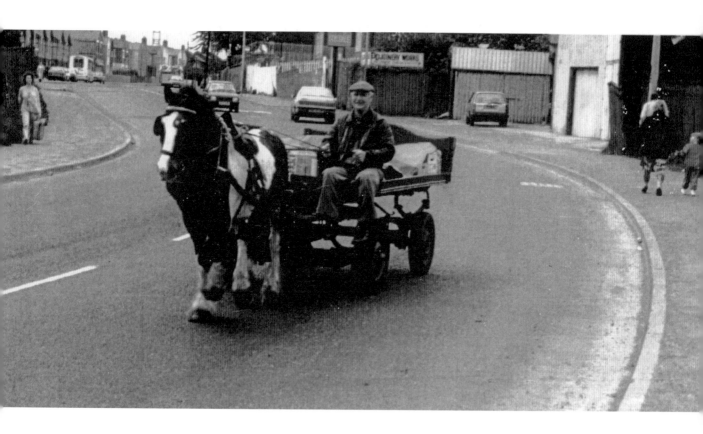

Hugh Kennedy, a carter and an old neighbour of
ours from Slate Street, driving his horse and cart
down the Springfield Road

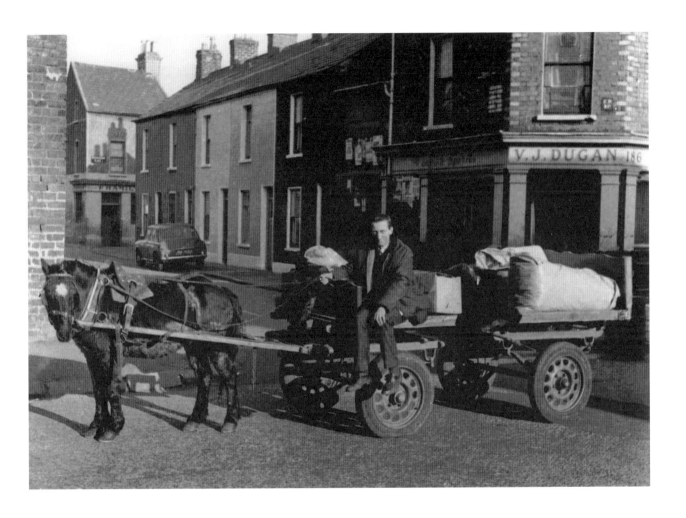

Ragman Mick Anderson with his pony Fury at the junction of Leeson Street and McDonnell Street. Gathering rags was a way of life in many of the poor districts of West Belfast. Mick Anderson would cross the divide between Catholic and Protestant areas to collect the rags. The children loved to hear him calling 'Any aul regs' – in return for an old shirt or coat he would give the children a large toffee sweet known locally as a Penny Dainty, which the children saw as a great treat.

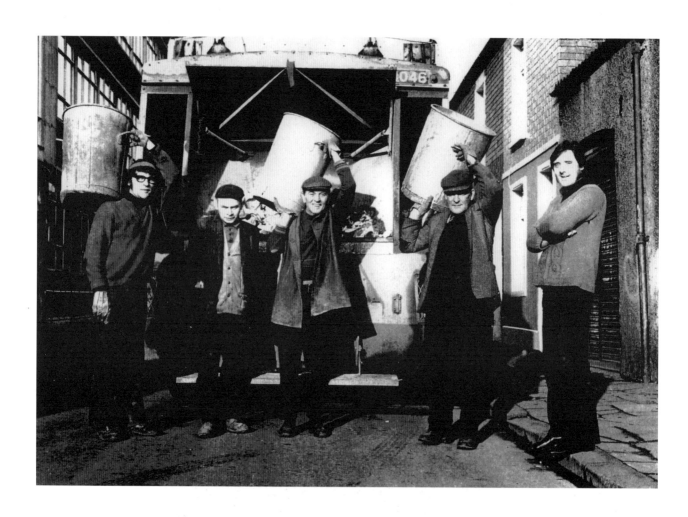

Binmen in Slate Street, L–R: H. Butler, Jimmy Kelly,
P. McKenna, John Prince, Sammy Morrow.
The binmen were the lifters and carriers, two
men to each bin. Once they had emptied the
old galvanised bins into the back of the lorry,
they would carry them through the houses and
into the backyards.

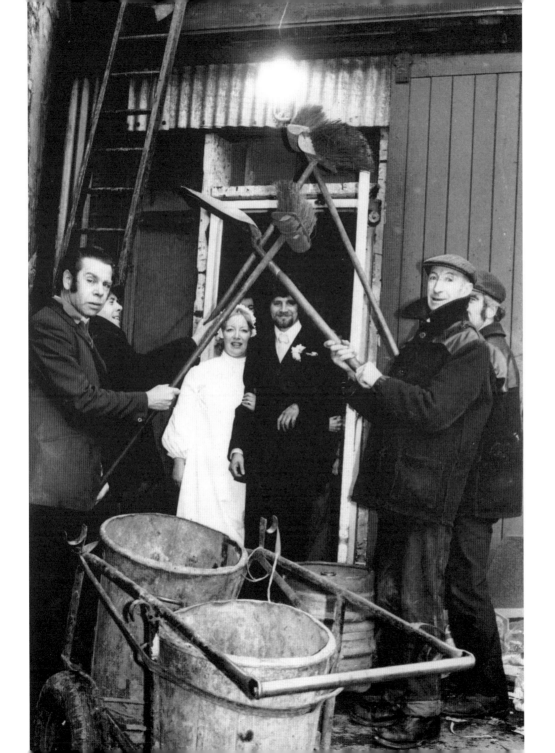

The binmen form a
wedding guard of
honour for Mickey
O'Hare and Betty
Dorrian at the Cyprus
Street Club on the
Falls Road.

My father Tim Dargan, foreman of
Robert Kirk's builders, and (right)
with workmates

Scrapyard dealer Packy
takes a well-earned break
from building work.

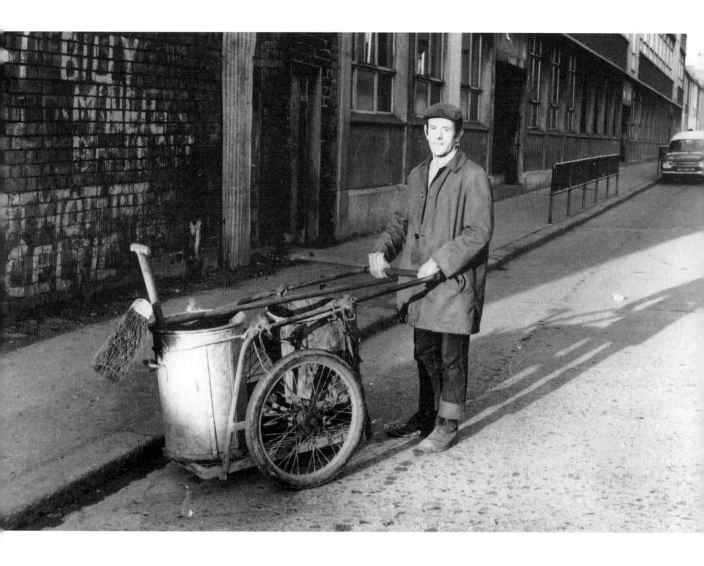

Paddy Doherty, street sweeper, followed the bin lorry,
clearing up anything the binmen had left behind. This is him
photographed on Slate Street.

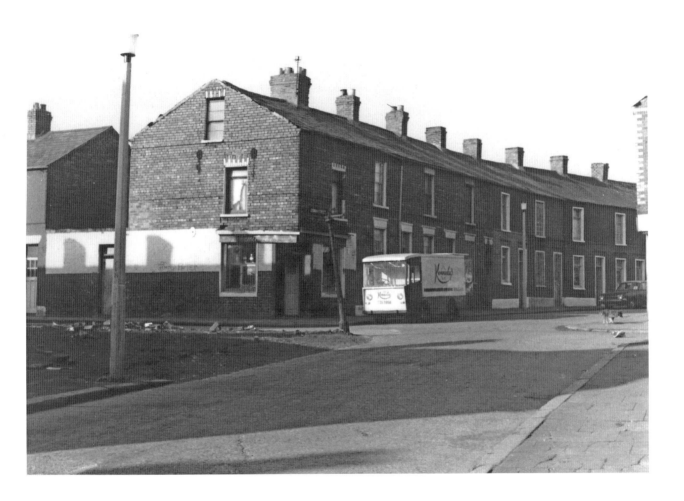

Gerry delivered bread to our neighbourhood in his freshly pressed brown overalls. An early riser, he was known as the quiet man – his battery-operated Kennedy's bakery box van made no noise. There was also a Barney Hughes bakery van. The baps, scones, barmbracks, diamond buns, soda farls, potato farls and Paris buns were delivered to the corner shops and to the windowsills of the surrounding little houses.

There were two pawnbrokers on the Grosvenor Road: Wells Bros, which was situated between Little Grosvenor Street and Arundel Street, and Joe Thompson's, on the opposite side of the road. Rather than saying they were going to the pawn shop, people used to say, 'I'm going to my uncle's'.

Joe Thompson's was at the junction of Cullingtree Road (strongly nationalist) and Grosvenor Road (a mixed area), and provided a service to both sides – an early exercise in cross-community relations. There was a side entrance in Cullingtree Road, which was mainly used by Catholics and the less well-off who had something to pledge. There was also a large window by this entrance that displayed all the unclaimed pledges that were for sale.

On the Grosvenor Road side of the pawnshop was the large front

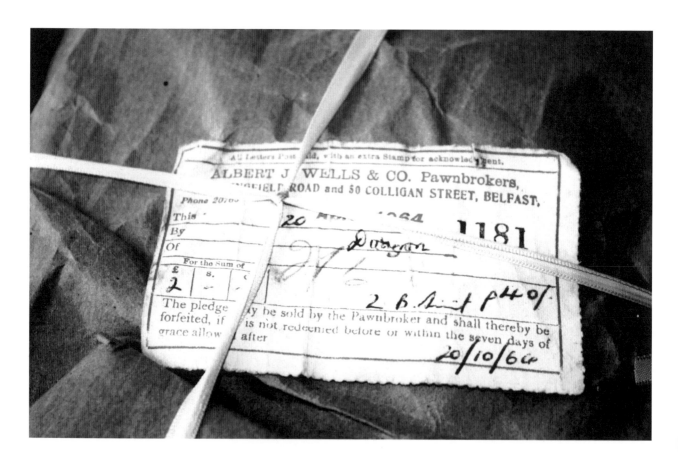

The perpetual parcel was a brown paper bag stuffed with old newspapers and tied up with string to make it look like something of value was inside. There were no questions asked – these parcels were always accepted.

entrance and an adjoining window displaying made-to-measure Orange regalia, such as sashes, collarettes and bowler hats.

Inside the pawnshop the customers with pledges were hidden from view, separated by wooden cubicles. Everyone with a pledge was called by their initials only. For example, Mrs Dargan was Mrs D and Mrs Kelly was Mrs K etc. You were then issued with a pawn ticket which was a record of your pledge and which stated the amount of money you had been given.

Sadly, during the civil unrest, Joe Thompson's pawn was badly damaged in a fire. Many people saw it as a great loss to their community when it had to be demolished.

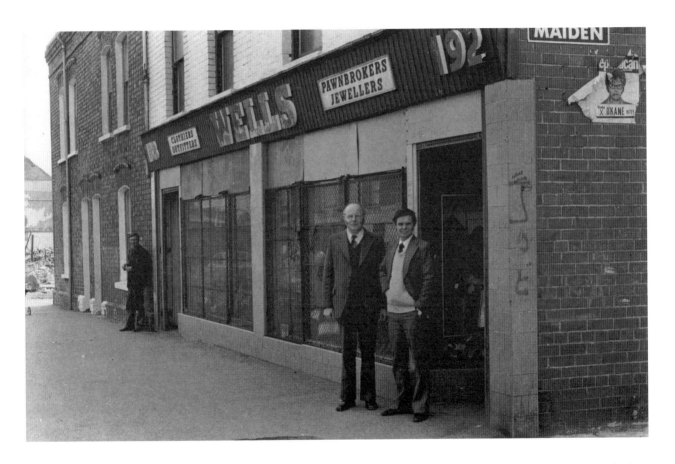

Wells pawnbrokers

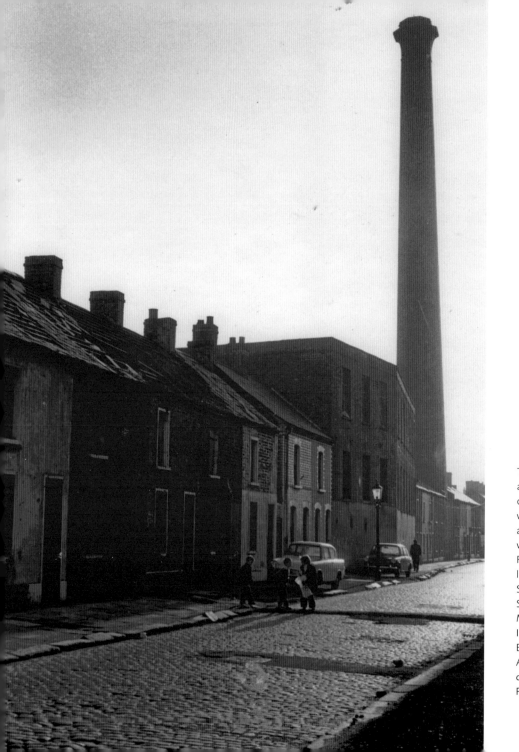

The Pound Loney (known locally as the Loney) was one of the oldest areas of the Falls Road. It was demolished to build Divis flats and Divis tower. The Pound Loney was aproached by Cullingtree Road off which was a series of little streets: Pound Street, Crane Street, Cinnamond Street, English Street, Bow Street, Scotch Street, Massareene Street, Baker Street, Irwin Street, Quadrant Street, Brook Street, Albert Street. Albert Street was known as the demarcation line between the Pound Loney and the Lower Wack.

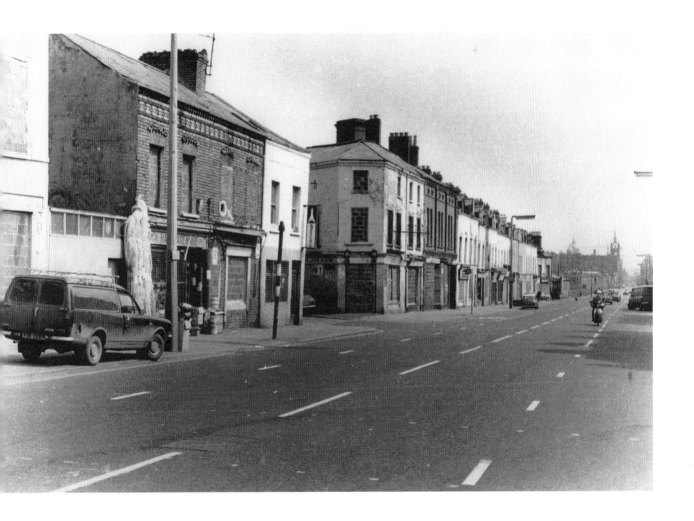

The Grosvenor Road reaches from Great Victoria Street in Belfast city centre to the Falls Road. There was an eclectic mixture of trades represented along it in the '60s and '70's, including Danny Farrell's hardware shop, Phillip Fusco's café, milk bars, ice cream parlours, pubs, a bookmaker, linen works, fancy goods, a music academy, a confectioner, a car hire company, a boot repairer, window cleaners, Mr Leitch's photography, hairdressers and Wilton funeral furnishers.

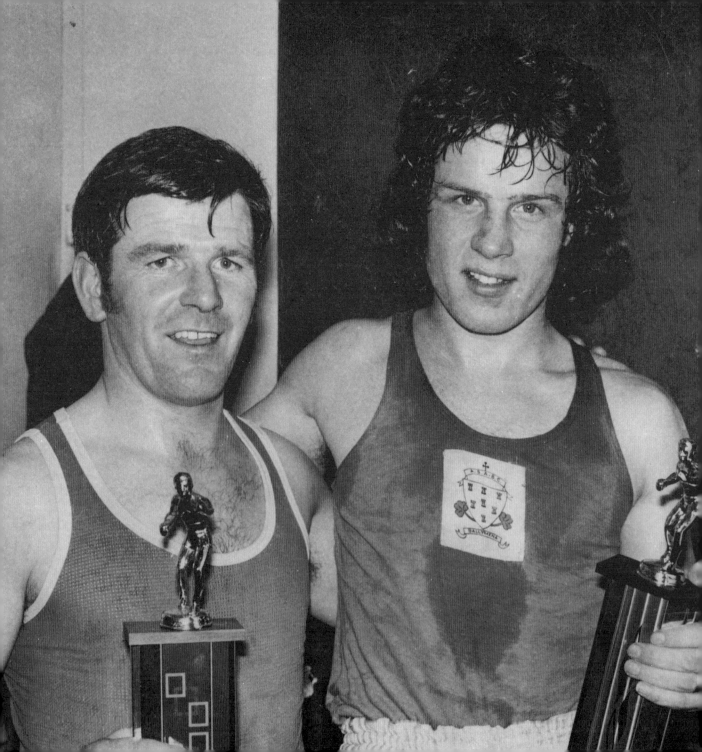

TIME OFF

There weren't many facilities on offer for the kids from the Lower Wack in the 1960s and '70s. There were no pitches on which to play football, so they used the street. They painted goalposts on the gable walls with white paint, meaning they could also be used by cricket and handball players. Very few kids owned a bicycle so they used to hire them by the hour from the West End Radio and Cycle Store in Leeson Street which was run by Jim McCourt's father. A favourite game involved two cyclists racing at each other at high speed from opposite ends of Cullingtree Road – the first cyclist to turn away to avoid the crash was called Chicken.

Adults made their own entertainment by joining illegal card schools, which were usually held at street corners and run by local men. They were very popular because of the large sums of money that could be won.

There were also the weekend dance evenings, usually held in their local church hall. If the ladies didn't like the showband or the group that was playing that evening, there was always a quiet game of Housey Housey (bingo) on the go.

During his time at the Immaculata ABC in Devonshire Street, Jim McCourt (who came from Leeson Street) won a bronze medal at the 1964 Olympics. Here he is on the left with an opponent from Ballymena after their fight for a club trophy. The event was held in Albert Street church.

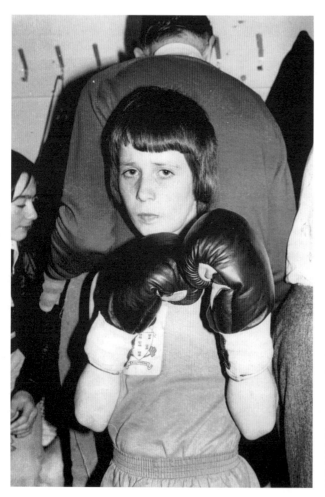

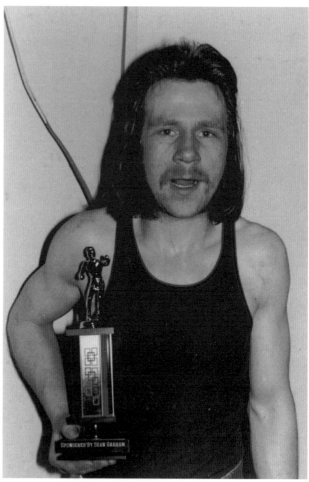

A young Ballymena boxer prepares for his fight.

Paddy Moore, an Immaculata boxer from Servia Street, holding the club trophy

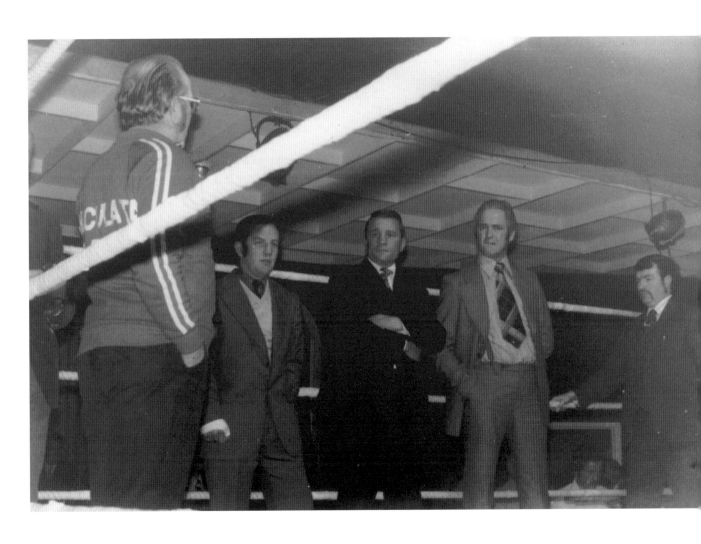

Immaculata coaches Ned McCormick, Eddie Shaw,
J. McAuley and P. Sharpe in the ring

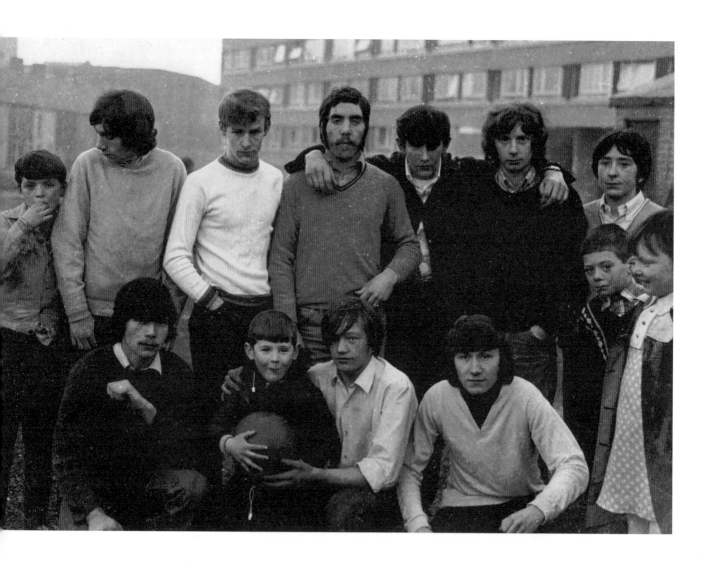

A crowd of onlookers and supporters gathers to
watch the five-a-side football. The Divis flats are
in the background.

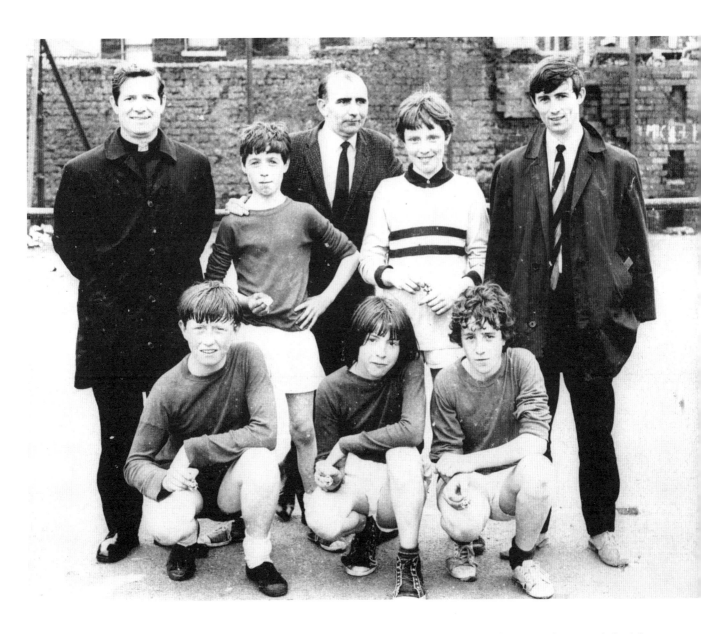

The Immaculata under-thirteen junior football team at their own pitch in Devonshire Street behind the old Cullingtree Road RUC Barracks in 1971. Back row, L–R: Father J. Burns, G. McKee, D. Kavanagh, D. Voyle, Jim McKee. Front row, L–R: J. McGivern, [first name not known] McCabe, R. Lowry.

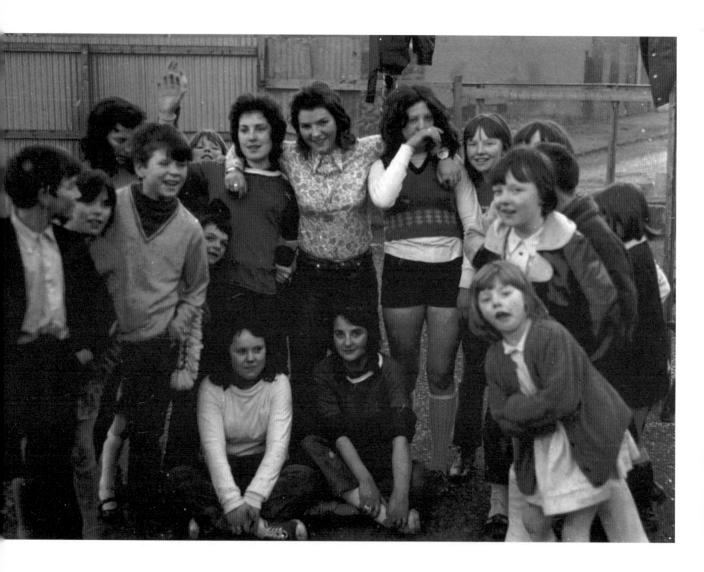

The Divis flats ladies football team and their supporters
gather at the pitch to watch the five-a-side matches.
Note the jackets hanging from the goalposts.

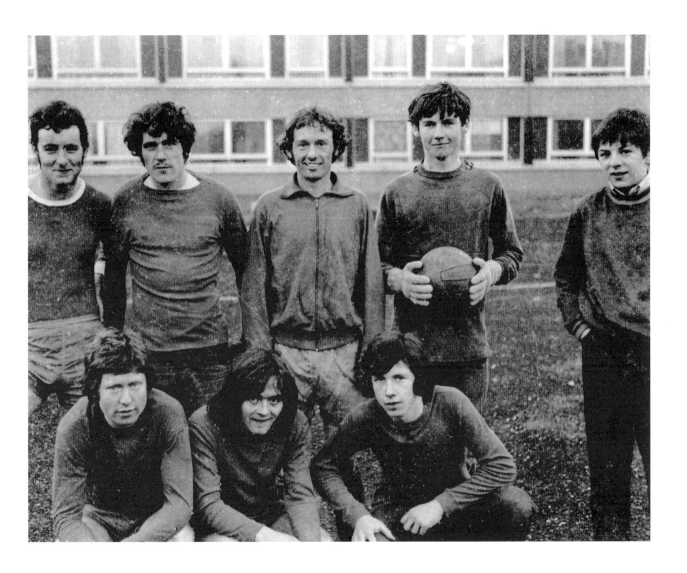

The Divis flats local team, after a game in a local
five-a-side tournament. The Divis flats are in the
background. Back row, L–R: R. J. Wilson, H. McGarry,
L. Clark, J. O'Riordan. Front row, L–R: D. Macaulay,
P. Prenter, G. Taggart. Hugh Straney is looking on –
he is now a DJ with his own radio show in Toronto.

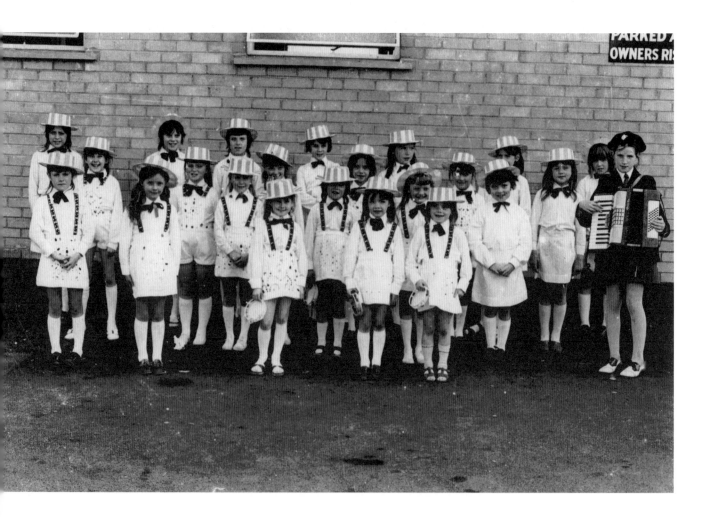

Tony O'Loughlin established the Divis Minstrels when he was a community worker on the Falls Road in the early '70s. Tony started the original group and ran it for several years. Some of the highlights from that time were the group's performance for the president of Ireland, as well as their participation in the St Patrick's Day parade in Dublin. They also played at many of the clubs along the Falls road and at community relations events.

The Divis All-Girl Minstrels arrive at the Irish National Forresters Club in Albert Street.

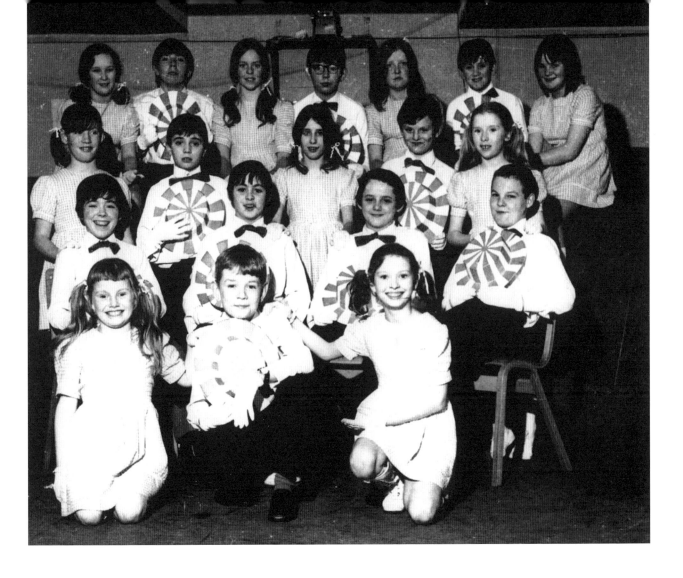

The Minstrels from the Cullingtree Road Youth Club, managed by Eileen McCabe and Margaret Irvine. Back row, L–R: C. Elliman, A. Rooney, T. Horrigan, T. Hughes, P. Donnelly, A. McCann, P. Armstrong. Second row, L–R: L. McDonald, G. Rooney, Kate McCann, John Canning, K. Kennedy. Third row, L–R: John McCann, D. Carberay, J. Irvine, S. Curley. Front Row, L–R: F. Mullan, J. Mullan, S. McKernan.

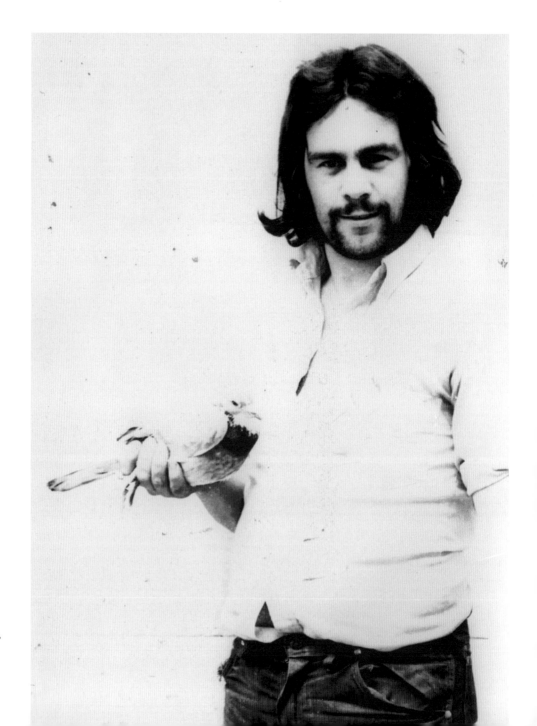

Seamus, a pigeon fancier,
photographed in Slate
Street in the early 1970s

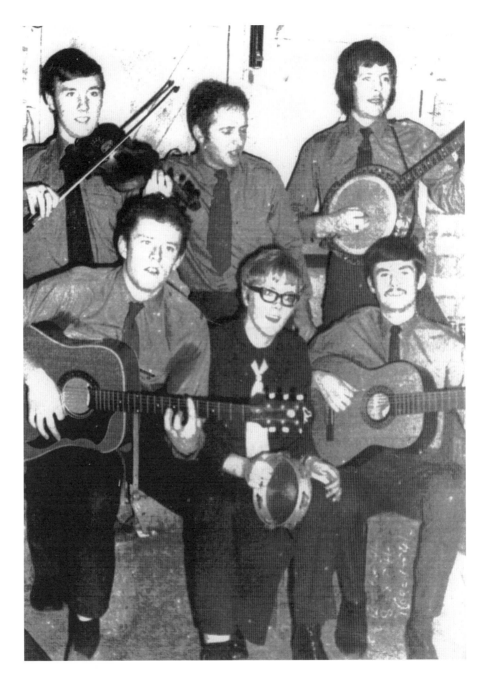

The traditional Irish folk group
The Flying Columb photographed
in St Mary's Hall, Coars Lane, in
the late 1960s

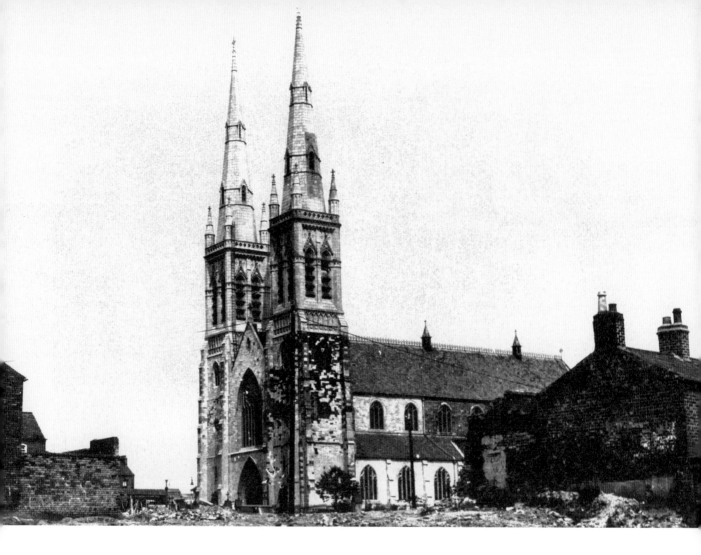

The beating heart of the Pound Loney, St Peter's Roman Catholic cathedral, was built in 1866, and its two spires can be seen from many different parts of Belfast. It was once surrounded by little Victorian streets, from Divis to Derby and from Albert to Milford Streets. The site where the cathedral was built was donated to the church by the famous baker Barney Hughes. The cathedral was refurbished in 2005 at a cost of over four million pounds. Local folklore states that not so much as a window was broken in the cathedral during the Belfast Blitz in the Second World War because Adolf Hitler personally issued strict orders to the Luftwaffe not to bomb it.

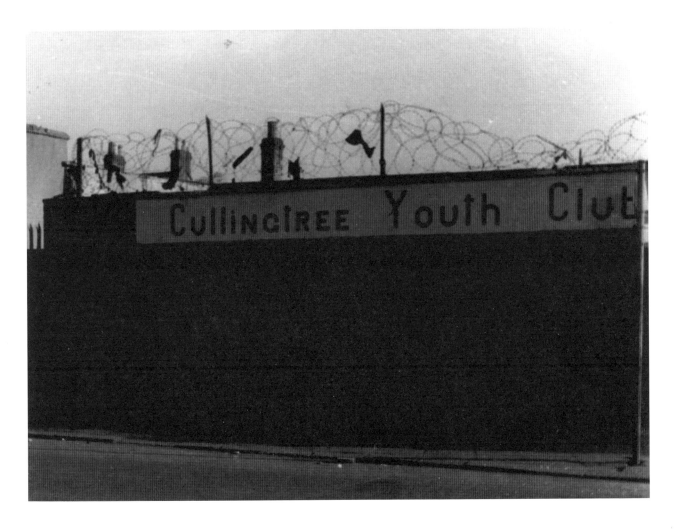

Cullingtree Youth Club (CYC) opened in the early 1970s in a disused welders' yard. It catered for all the youth from the Falls area, and played an important part in keeping the youngsters from getting involved in local rioting. It was on the Lower Wack side of the Cullingtree Road, closer to the Grosvenor Road. The Pound Social Club was also in the same area. The building had previously been a bottling store for stout and ale and had been owned by Lyle & Kinahan. There is said to be a freshwater spring flowing beneath the building. Today there are streets of new houses where both clubs used to be.

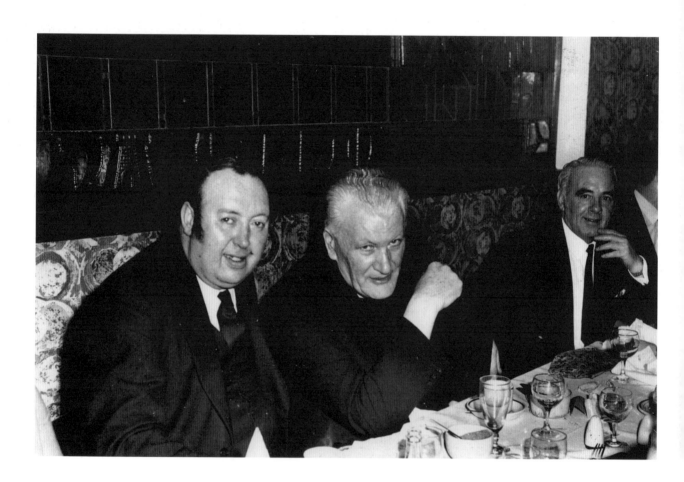

The Silver Thread Club was in Divis Street. It was established for senior citizens from the Falls Road and further afield. It was run by Tommy Magee, who was from Bangor, and who is on the far right of this photograph. Special guests were invited on a regular basis: with Tommy on this occasion are Paddy Devlin MP and Canon Murphy.

Here are two regular visitors to the club, Rosie McCabe and Kitty McAlholme from the Pound Loney, enjoying the party.

The West Belfast caterers. Although the business was based on the
Shankill Road, they catered for almost every party on the Falls.

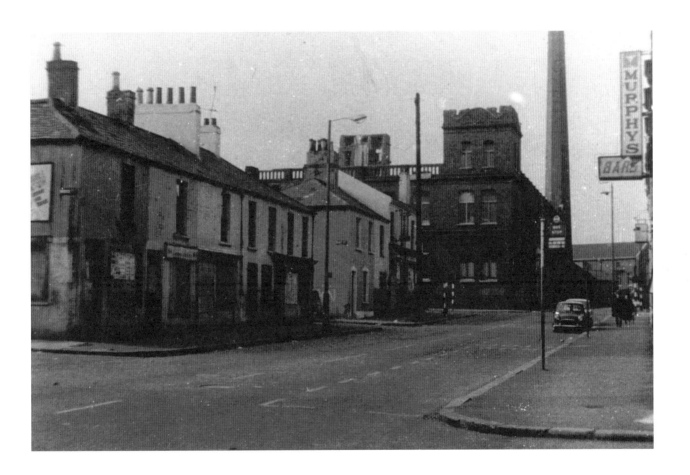

This photograph, taken in the 1970s, gives truth to the saying that every street corner on the Falls Road had a pub on it. This is Albert Street, the demarcation line between the Pound Loney and the Lower Wack. On the left is Mary Street with the folk music pub, The Oul House, on the corner. On the right is Murphy's.

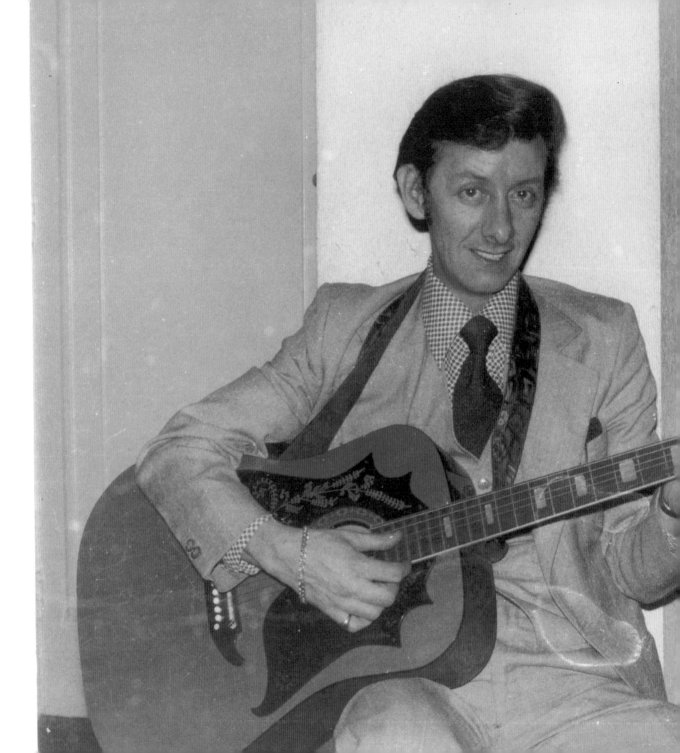

Part of the original Sheriffs'
line-up: Brian McShane
– Belfast's Dean Martin –
and Hugh (Hugo) Dargan,
photographed at my wedding
reception in 1976. I would have
completed the line-up, but I
was taking the photograph!

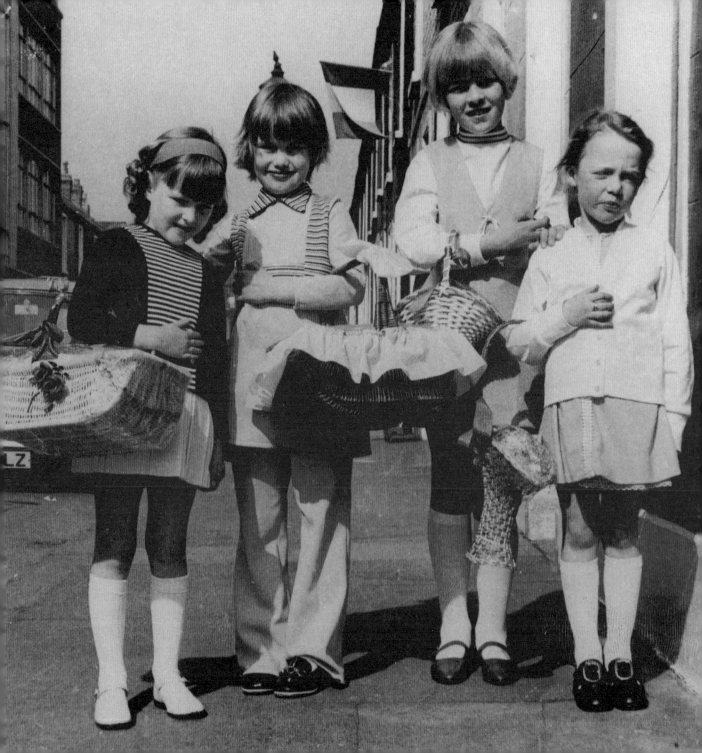

CELEBRATIONS

There were many causes for celebration in the community of the Falls: Easter, Christmas, birthdays, baptisms, First Communions and weddings, to name just a few. The Easter celebrations were especially popular with children. After Easter Sunday dinner, children were given their chocolate eggs – usually in boxes for the boys and in baskets for the girls. The children then set out to visit grannies, uncles and aunties where they were likely to receive more presents, before meeting up with their friends to compare their haul.

Another important Easter tradition was egg rolling. The eggs were usually prepared a few days before Easter Sunday – they were hard boiled, sometimes in tea leaves to make them a dark brown colour, and then painted. Then the children and their families would board the bus to Belfast Zoo, at the foot of the Cave Hill. This was an ideal place for egg rolling – although you had to be very energetic to chase after your egg before it got lost in the grass or even crashed into a tree.

My niece Kathleen Dargan (third from left) meets up with friends in Slate Street to compare Easter eggs.

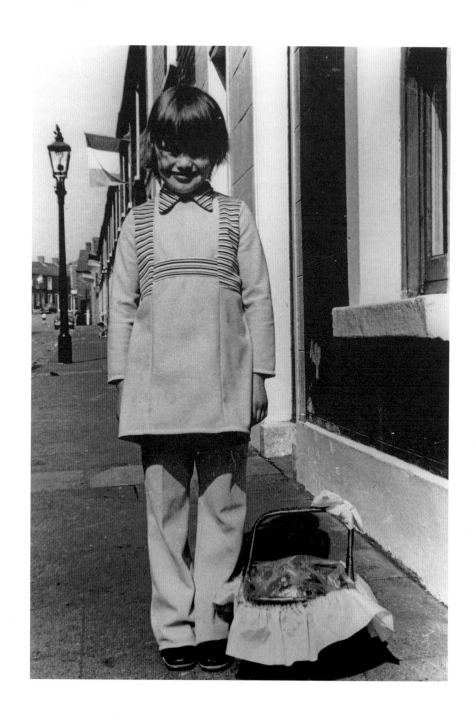

Kathleen ... with all her eggs
in one basket

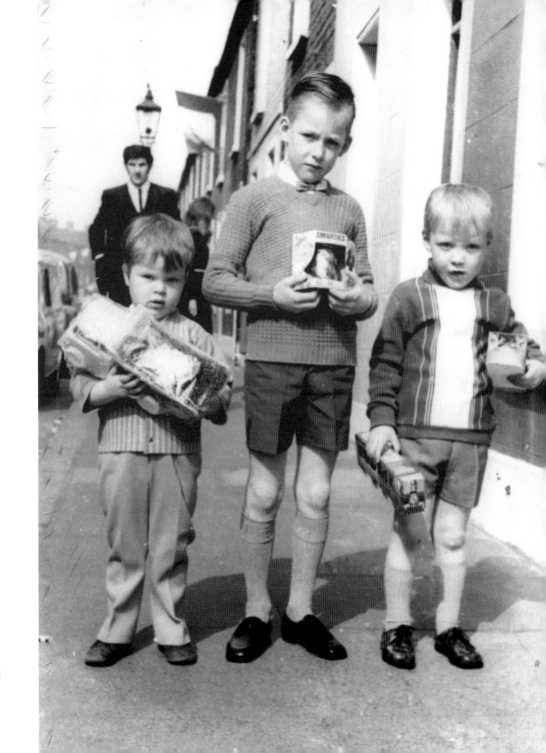

My nephews Hugh (middle) and Thomas (right) Dargan, and a friend show off their presents outside their granny's house in Slate Street. Neighbour Jim Mervyn is walking along the street in the background.

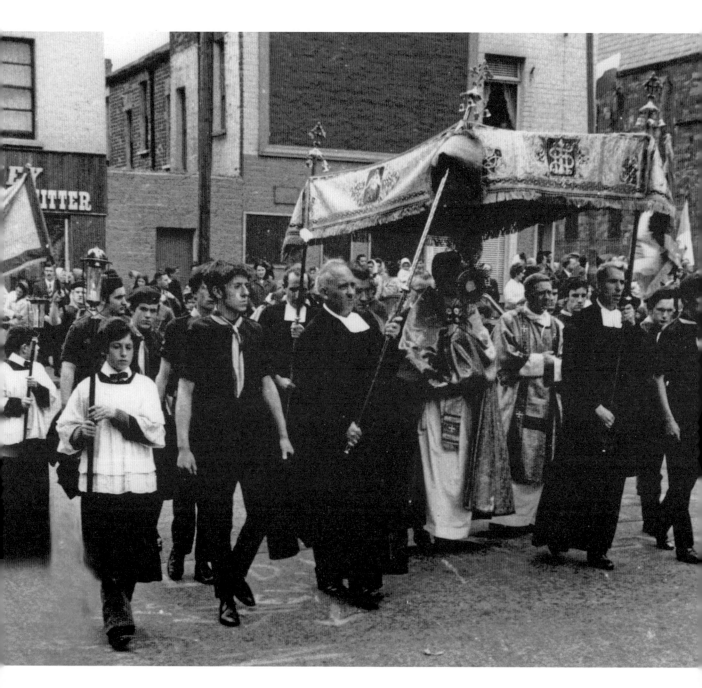

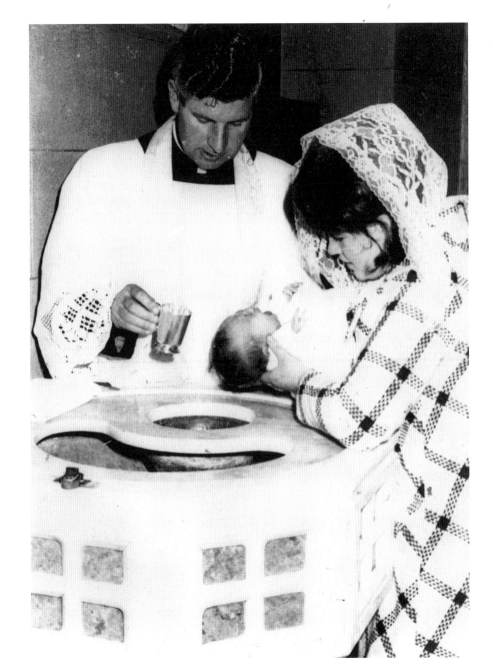

OPPOSITE
A Eucharistic exposition through
the streets around the Falls.
Here, the participants are
emerging from Raglan Street on
to Albert Street on their way back
to St Peter's cathedral. At the
front of the procession is altar
boy A. Russell and boy scout
Carlin; you can see Father
J. McCabe on the far right.

Father McCartney baptises a
baby at St Peter's.

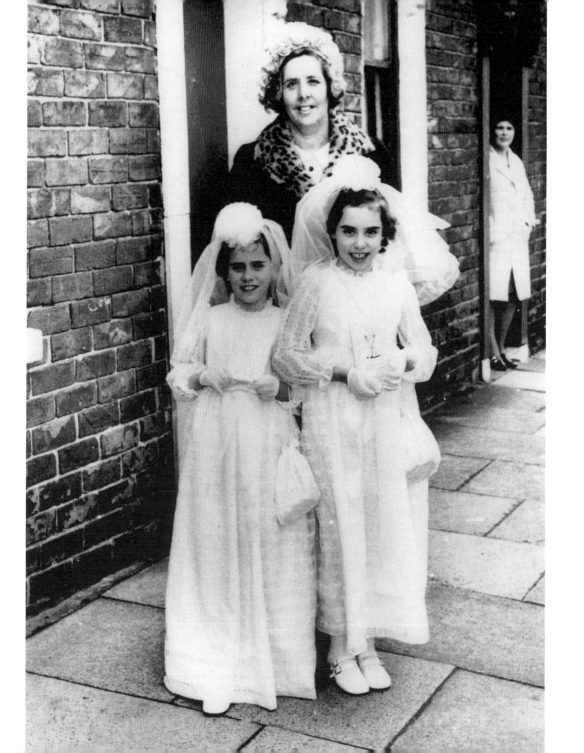

Shortly after Easter, in May and June, schools were very busy preparing children for the big event of their First Holy Communion. There was great emphasis on the children learning their prayers for their presentation to receive the sacrament of Holy Communion. By tradition, the girls wear white dresses and the boys usually wear a suit for the first time. It is good luck to see a child going to receive their First Communion in the street and the onlooker usually gives the child some money. These two girls are in white from head to toe, photographed in Cullingtree Road.

After a happy and eventful day, these two children enjoy a sit-down on a neighbour's windowsill.

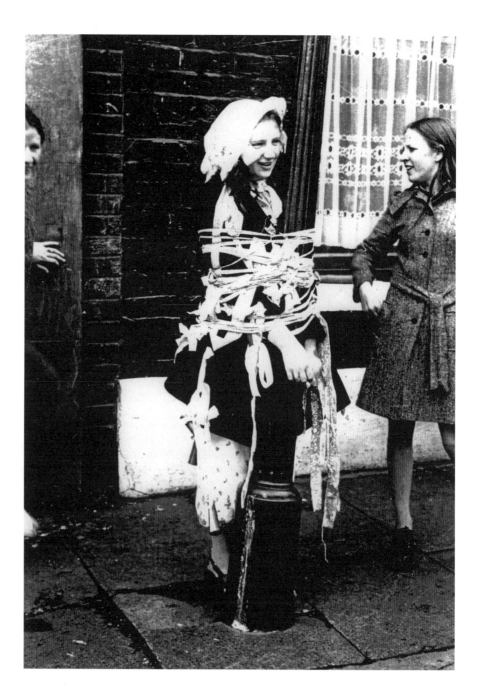

A rite of passage for the bride-to-be before her wedding day: first the bride (a local girl called Geraldine Black, in this case) is tied to a lamppost with ragged ribbons and rope – and can remain there for many hours for all the world to see. Sometimes passing members of the public are encouraged to throw rotten fruit and bags of flour. Then, before the bride is released, her best friends throw almost anything that comes to hand at her.

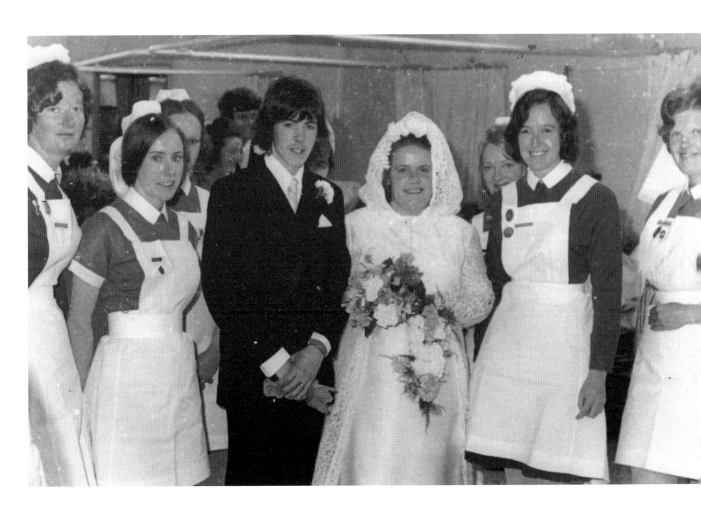

This bride and groom made a special visit
to see the bride's sick mum at the Royal
Victoria Hospital after their wedding.

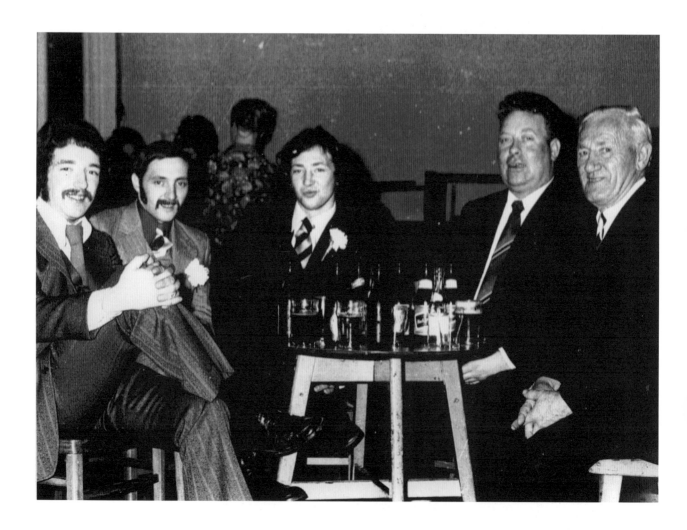

Black-and-white wedding photographs were the choice of many a bride and groom in the '60s and '70s as opposed to colour photographs, which were still very expensive at that time. A twenty-print black-and-white album cost between ten and thirty pounds. In the majority of cases, money was scarce and extended families and friends helped make the day special for the bride and groom. Weddings were less lavish then – the guests wore their Sunday best, and there was usually only one bridesmaid, as in this wedding, which took place at St Peter's. The wedding reception was usually held in one of the local social clubs, like this one, which took place in the West Club.

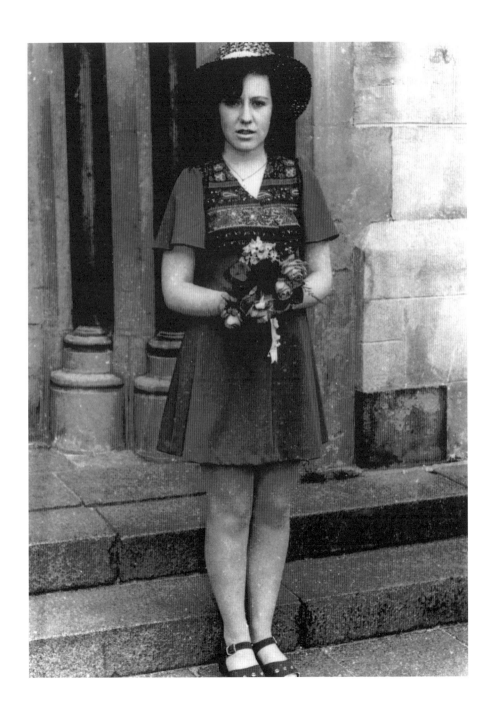

A bridesmaid outside St Peter's

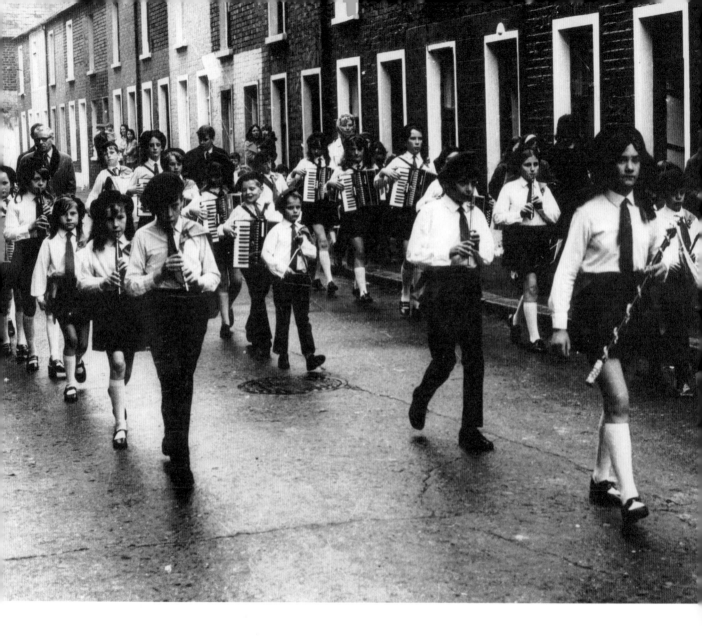

Band instructors Billy McAllister senior and his son Billy
junior keep a watchful eye on the Terence Perry Band
as its members move through the streets of the Falls.

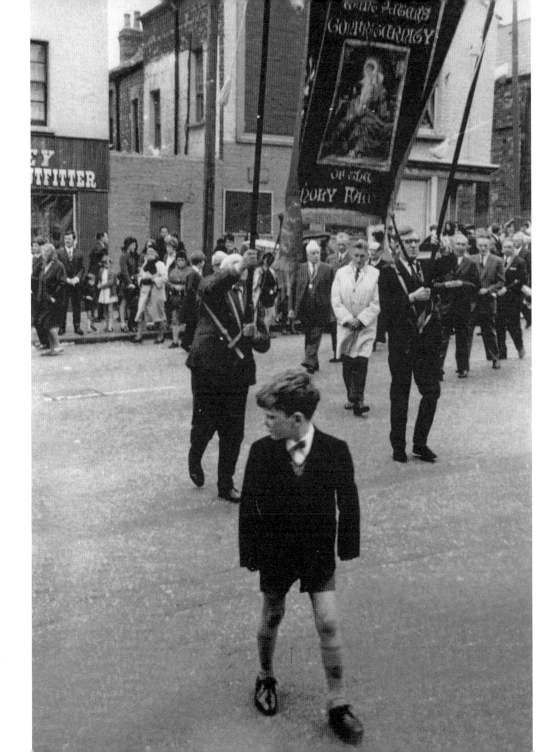

A Corpus Christi procession makes its way down Albert Street on the way back to St Peter's.

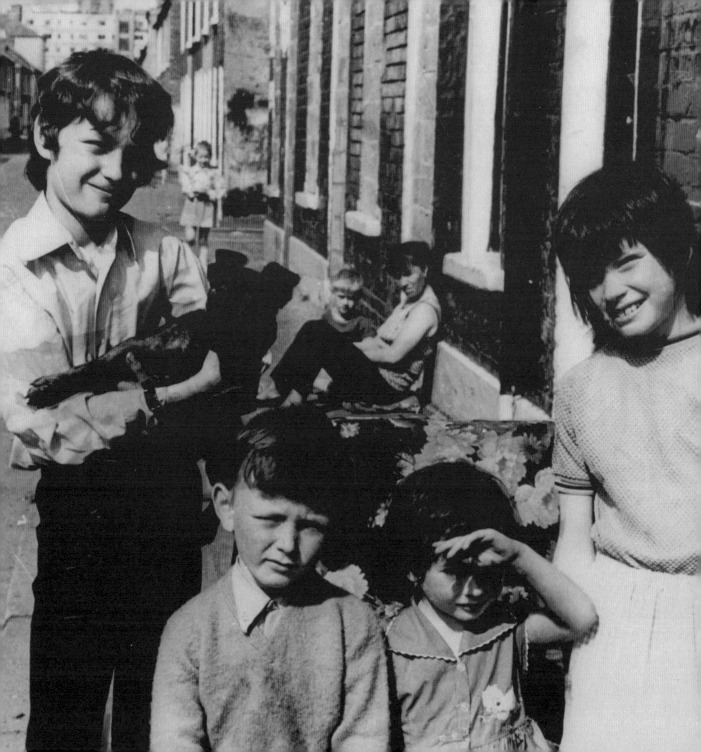

NEIGHBOURS

When I lived in the Falls, everyone lived with their families in the same poor-quality housing. In some cases there would have been two families living in the same two-bedrooom kitchen house. Still, if anyone was in need, neighbours helped out. When there was a death, for example, the whole community would rally around. If there were young children in the family then they stayed with a neighbour until the day of the funeral and the women from around the neighbourhood made dinner and tea for the people who came to the house to pay their respects. When the body was brought home, the men closed all the blinds, and covered all the mirrors in the house of the person who had died and gathered for the wake.

The Duffin family in McDonnell Street with neighbour Crissey McCorry sitting in the background

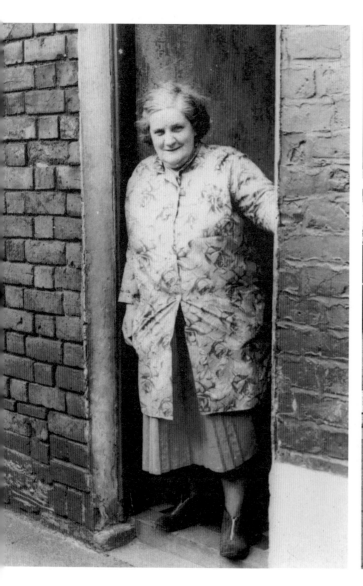

Miss Agnes McCluskey standing at her door in Slate Street

Mrs Bridget Mervyn walking down Slate Street with Osman Street in the background

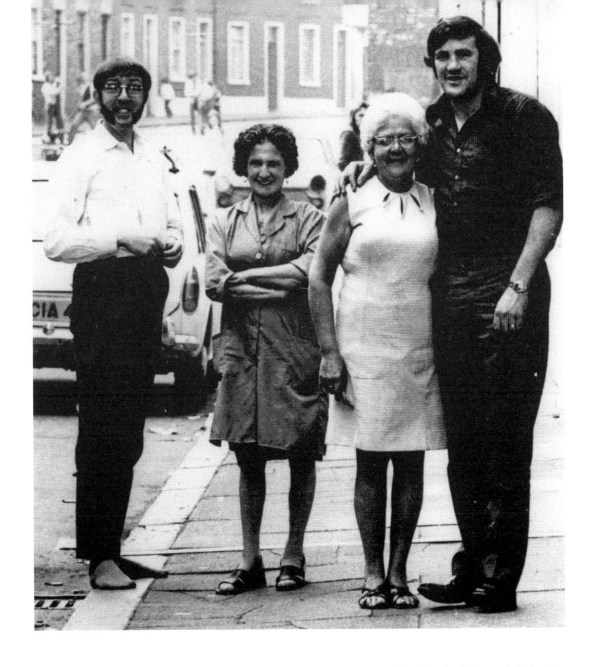

Slate Street friends and neighbours: L–R: Joe Fox,
Mrs Maggie Hall, Mrs Winnie Brown and Charlie Mervyn

Another Slate Street
neighbour, Jimmy McCluskey,
a fluent Irish speaker

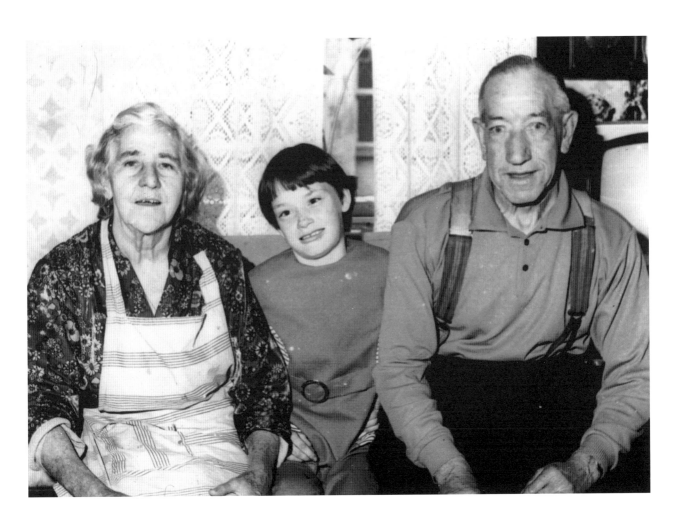

Mr and Mrs O'Connor with their niece Margaret Duffin. If the
O'Connors saw me passing, they'd ask me to come in and sing
for them. More for companionship than my singing, I think.

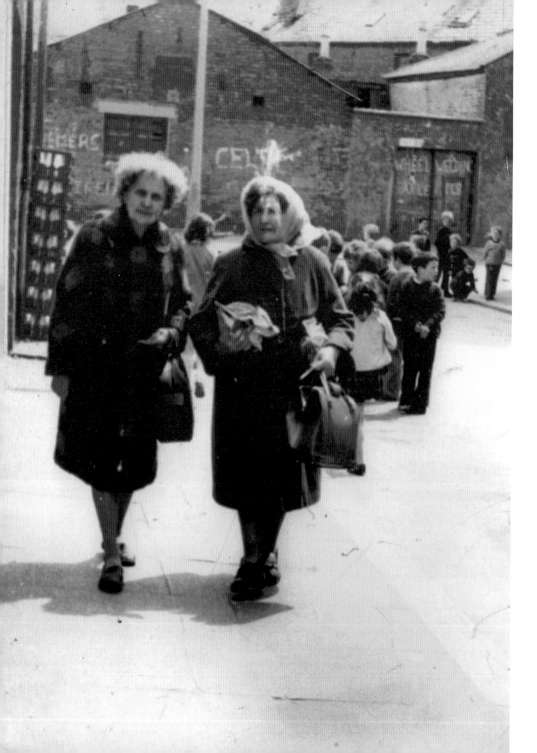

Mary Jane Connolly and my mother Kathleen. Mary Jane was well known for her charms – if you had a sore throat, or the palate at the roof of your mouth had dropped, or you couldn't speak too well, she had a charm that soon made you better, but she used to say that it wouldn't work if you said please or thank you. So you were in and out of her house almost without a word.

The well-known Falls Road character (Gerard) Bunny Rice. Born to Thomas and Elizabeth Rice (Banbridge people) in 1901 at 11 Balkan Street, Gerard was the youngest of six children. Thomas was a master weaver but he was not in good health. Bunny left Milford Street school at the age of twelve and at the age of fifteen he joined the Royal Dublin Fusiliers and the Royal Irish Rifles, and was sent to India and Turkey during the First World War.

During a period of unemployment, he had a yearning to learn to swim, which he did at the Falls Baths. He also swam in the River Lagan, at Greencastle, and also at Belfast harbour where the Bulkies often chased him. He became a strong swimmer.

At the outbreak of the Second World War he enlisted as an army medic and served during the Dunkirk evacuation, where he attended the wounded, carrying them on his back to the rescue boats out in the sea, during heavy German bombing. This method of swimming and carrying went on for days and sometimes Bunny saved as many as twenty wounded men each day.

Although Bunny survived, he developed shell shock, and was discharged with a pension of just sixteen pounds a month. He returned to Belfast and sadly became an alcoholic. Bunny was often seen walking the streets around the Falls Road, and was well known to local children, especially for his infectious laugh.

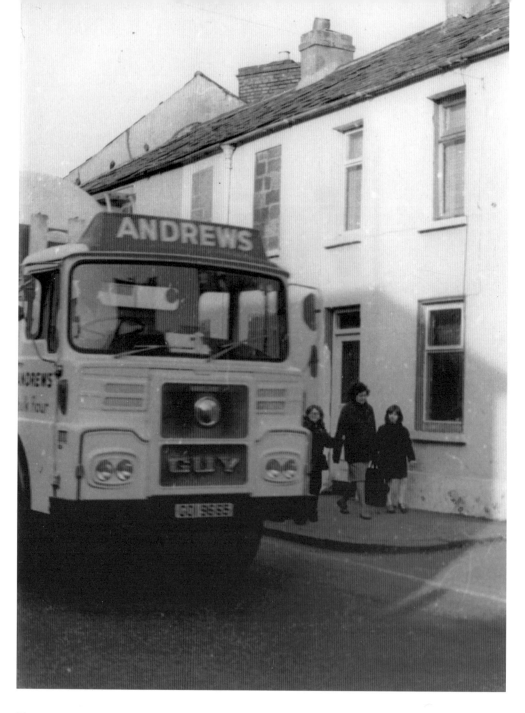

Neighbours on Durham Street squeeze past the Andrews lorry.

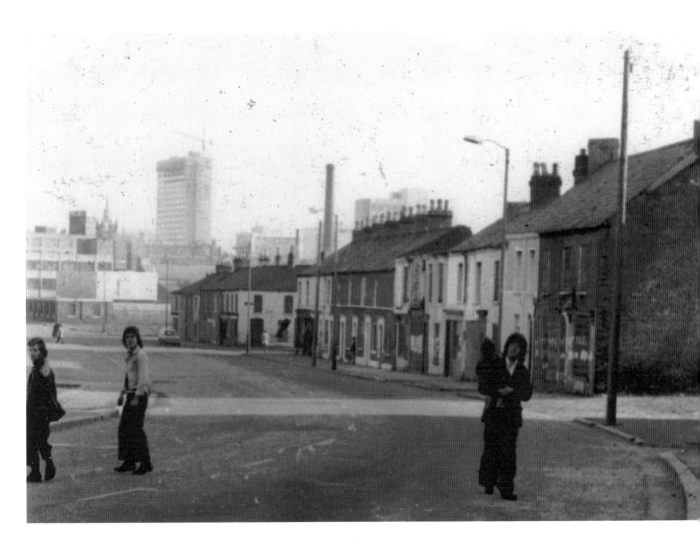

Johnny Donnelly's Arcadian Picture House – known locally as the Arc – was in Albert Street. Pat Mervyn was the uniformed usher and Mick Cavanagh was the doorman who collected the 1 pound and 2 empty jam pots that got you and your mates in to see the picture. If it was a cowboy film, there was usually a stampede out of the cinema at the end as the kids got on their imaginary horses and, slapping their sides and waving their imaginary guns, started shooting everything in sight. Imagination is a wonderful thing when you are ten years old.

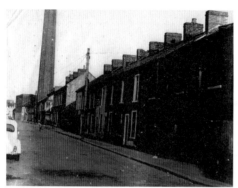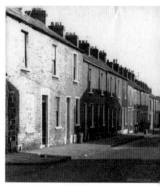

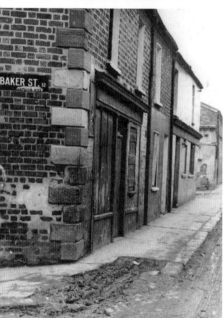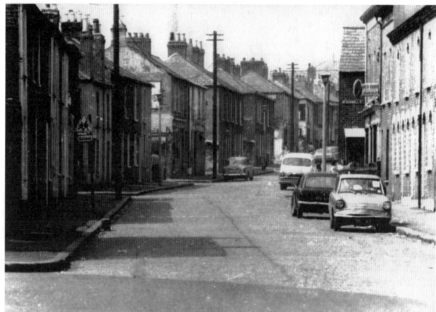

Top row, L–R: Cullingtree Road and Pound Loney, Murdoch Street, Leeson Street, Theodore Street, Slate Street, Wee McDonnell Street. Bottom row, L–R: Baker Street, Leeson Street, Durham Street, Distillery and Little Distillery Street. Growing up, we knew these streets like the backs of our hands, and we'd have felt able to call for dinner with almost all the neighbours who lived in them.

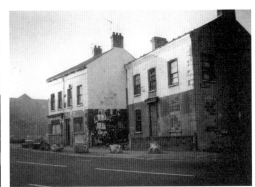
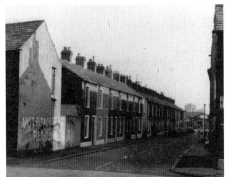
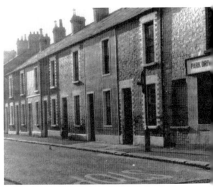

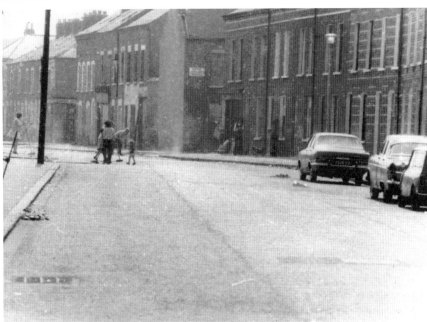

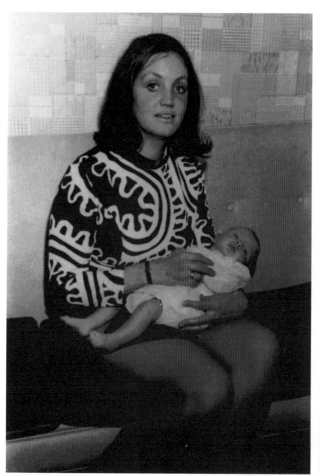
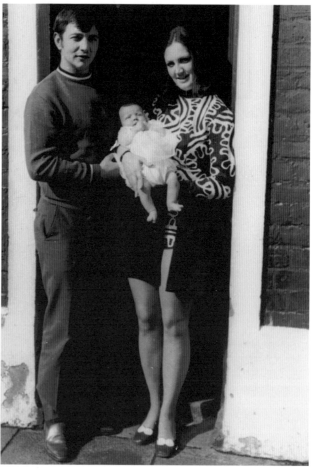

Jeanie Mervyn and Taffy with their
newborn baby in Slate Street

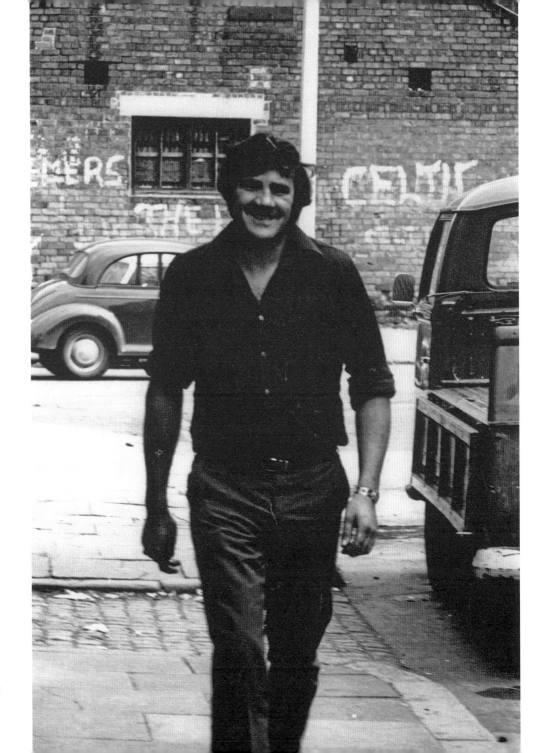

Charlie Mervyn
walking up Slate Street

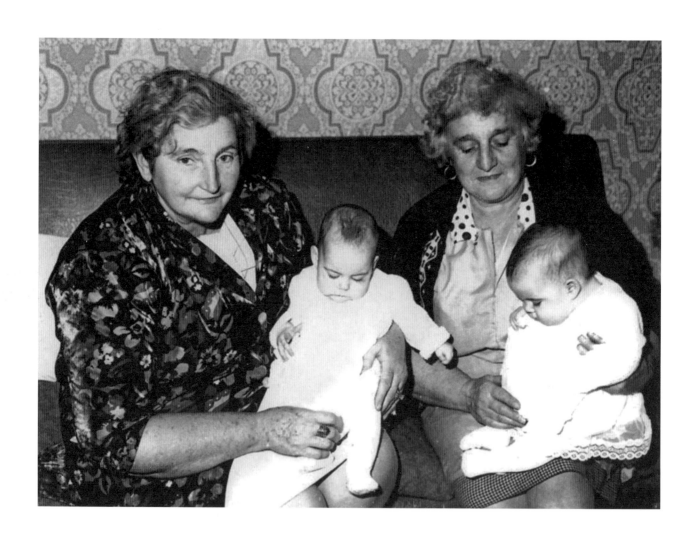

Charlie Mervyn's mother Bridget with her sister-in-law
Mary Ellen, and Bridget's twin granddaughters

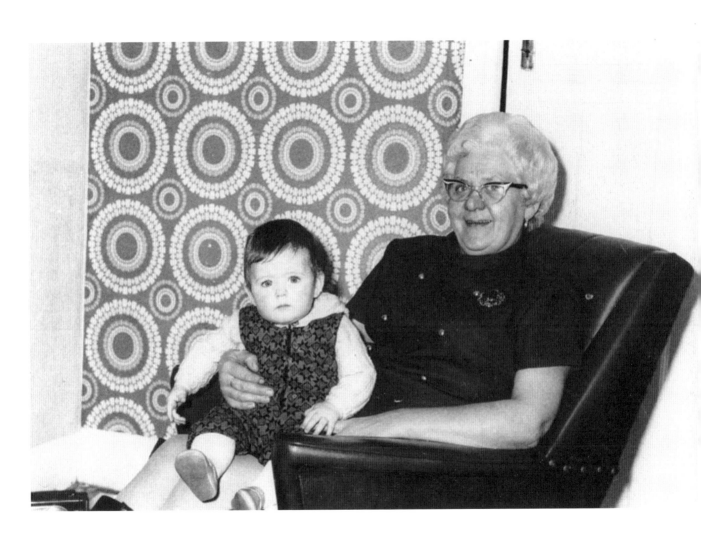

Winnie Brown, the wife of Eddie the milkman, with her granddaughter Lisa, at home in Slate Street

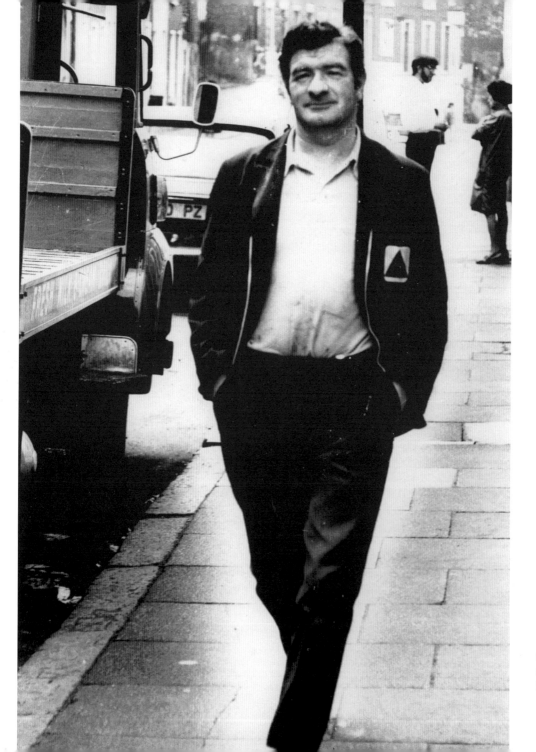

Gerry Gargan,
a lorry driver for
Bass Ireland

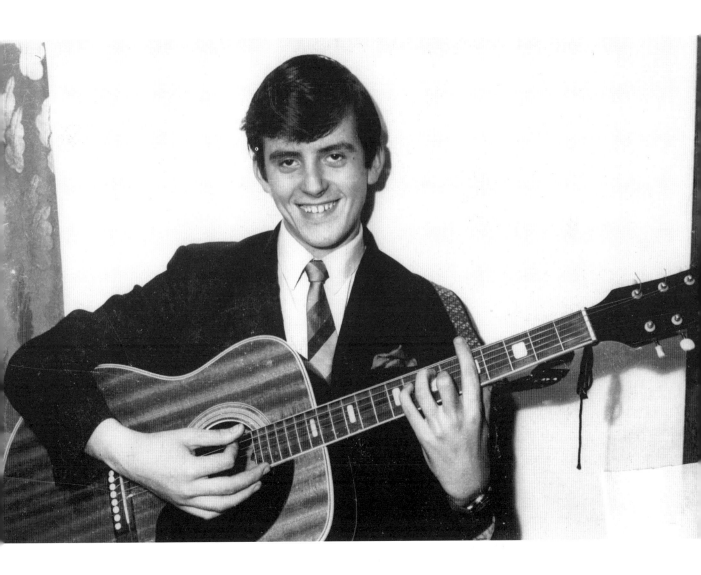

Harry McAleese, aged 23, a trainee solicitor and
a brilliant guitarist, photographed at our house in
Slate Street. Harry was killed on 16 April 1976.

Maggie and James Madden from McDonnell Street enjoying their holiday in Ballyhornan with their grandchildren. In the centre of the photograph is Martin Madden, who today is a guitarist in a showband called The New College Boys.

The Maddens were a very musical and talented family. The neighbours loved it when James sat with his front bedroom window open and played his Hawaiian (steel) guitar. The beautiful sound echoed all around the nearby streets.

Every weekend two of James's sons, Tommy and Paddy, would arrive at the top end of Slate Street, playing their guitars. This would draw in the wannabe guitarists, like me and my brother Hugh, who hoped to pick up a few chords from the experts. In a way, it was just an excuse to have a street party. It never took long for more talented singing and dancing neighbours to join in the fun.

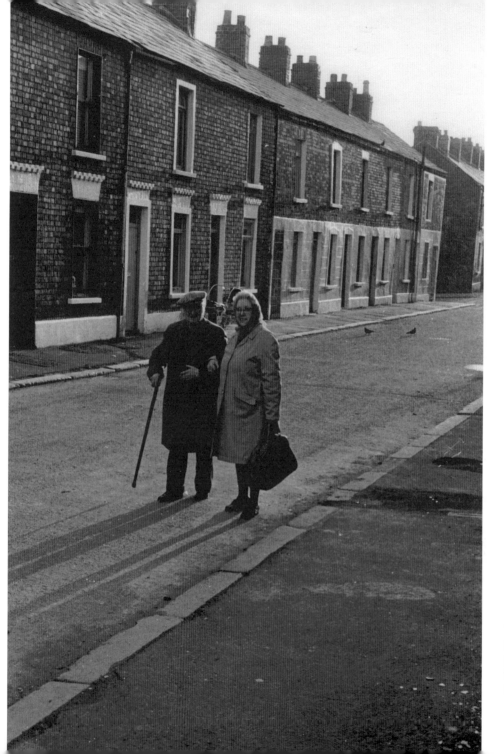

Taking a wee dander around the old streets. This photograph was taken from the Albert Street end of Servia Street.

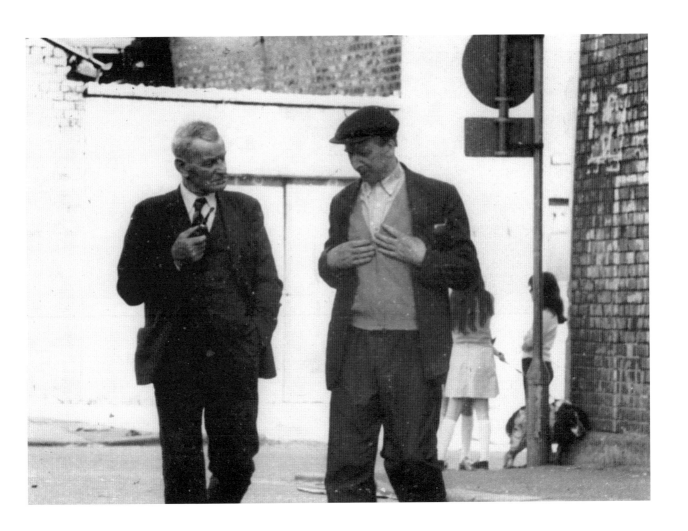

Two old neighbours (my father Tim is on the left) walking back from the bookies – looks like the odds were bad. The children in the background are playing at the junction of Slate Street and Cullingtree Road.

Neighbours from McDonnell Street gather the
children from their street games to have their
photograph taken.

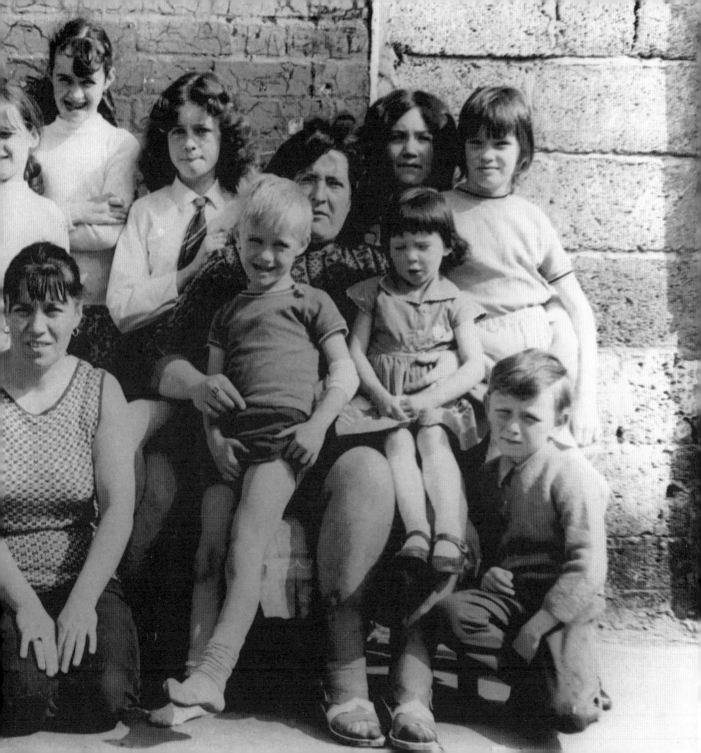

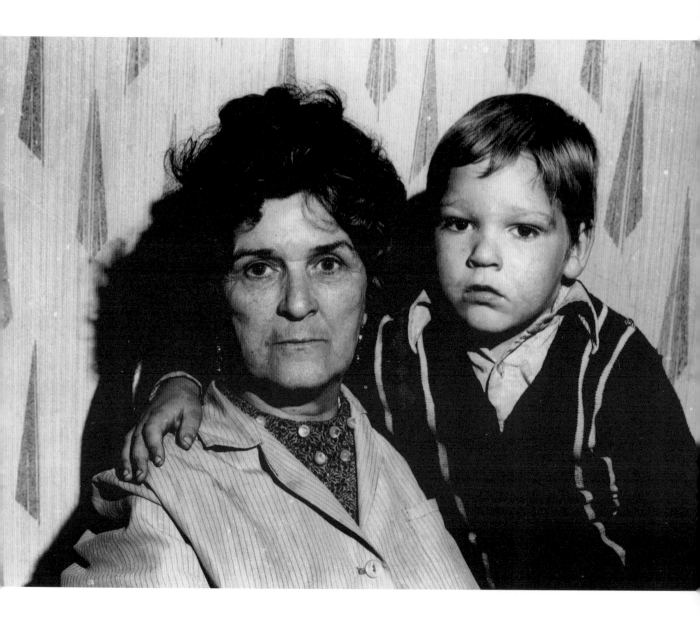

I don't have the names of this grandmother and
grandson – this family was one of the many who
asked me in to take a set of pictures, for which I
charged them less than a quid.

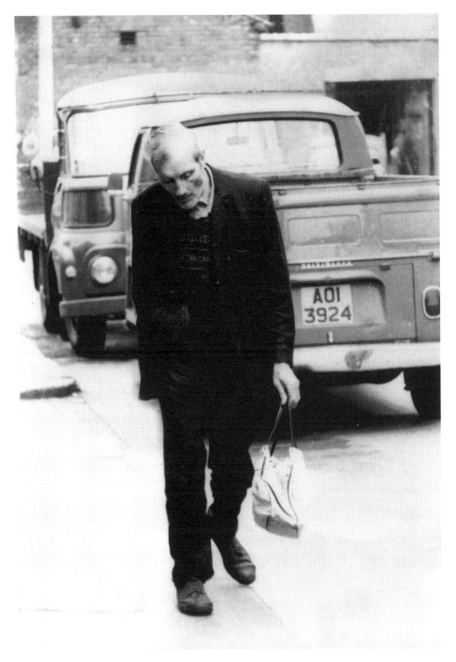

Willy Timony, an old resident of Slate
Street, making his way home after a
shopping trip. Eddie Brown's milk van
is in the background.

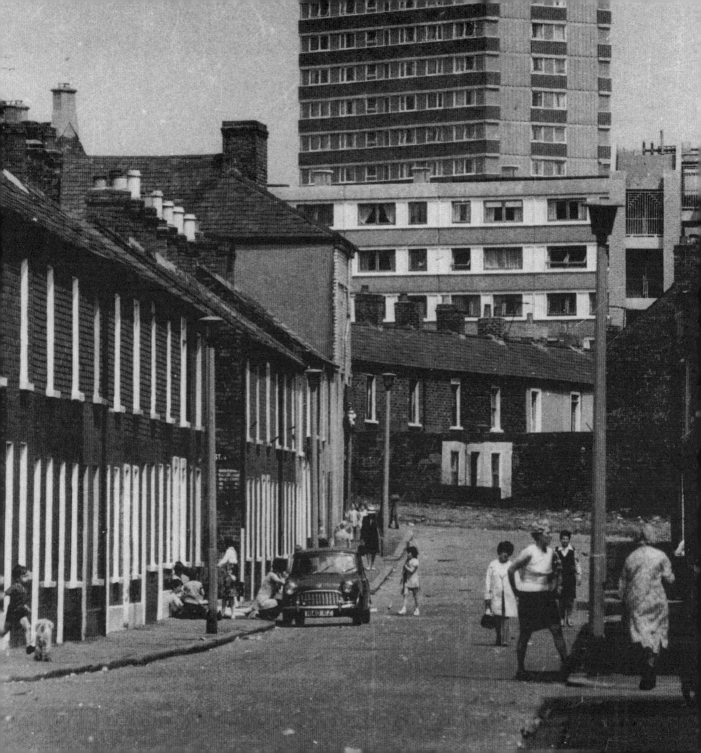

CHANGING TIMES

The photographs that I took in the 1960s and '70s capture the history of the Falls Road during a period of great change, though I wasn't conscious of that at the time. Extensive housing redevelopment to make room for the construction of the Divis flats complex and Divis tower, the outbreak of the troubles and the arrival of the British army meant that the community that I had grown up in would never be the same again.

The demolition of houses destroyed established communities and the ongoing civil unrest left many people sceptical about the prospect of peace for their families. The result was an exodus of people from the Falls Road area – hundreds of people left, either settling as squatters in safer places or moving even further away, to the Republic of Ireland. Some of those who left never returned to West Belfast.

The juxtaposition of old and new. The Divis tower – twenty storeys, and over sixty metres high – stands behind the old housing of McDonnell Street, where people are going about their normal business. From the 1970s, the British army had an observation post on the roof of Divis tower and occupied the top two floors. It closed in 2005. The tower is the only part of the Divis flats complex that is still standing today.

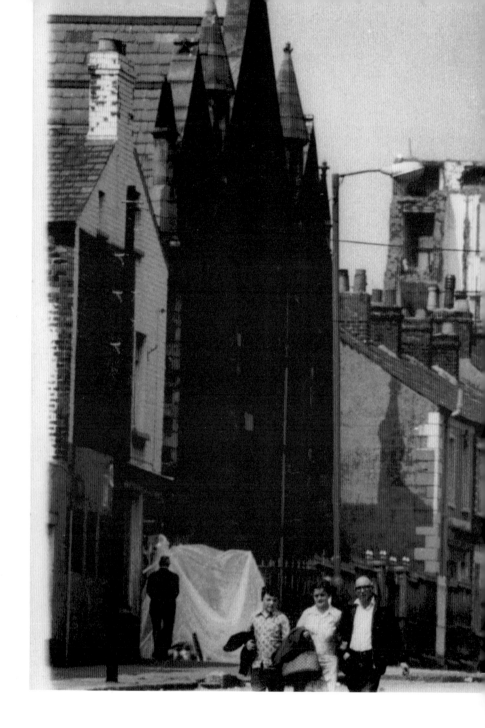

People going about their daily lives amid the destruction, c.1969. This photograph shows the burned-out Northern Flax Spinning and weaving mill, with a British army look-out post on top of it.

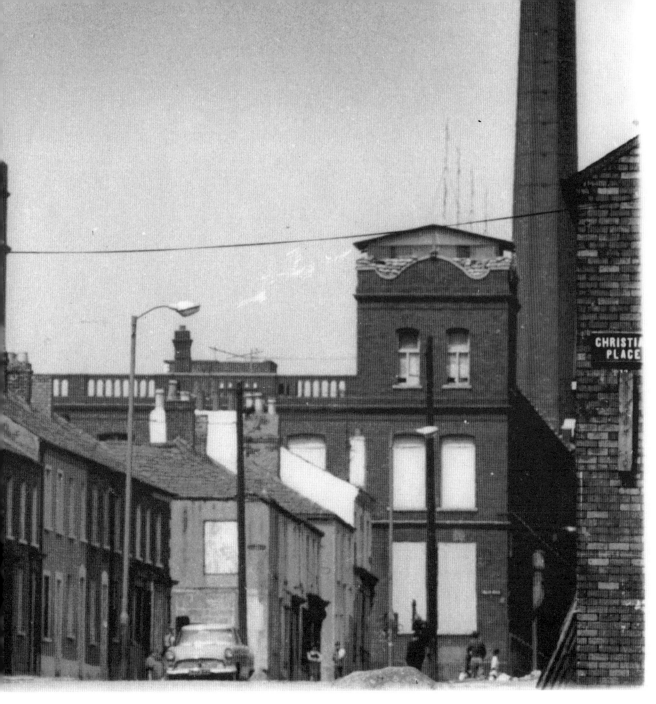

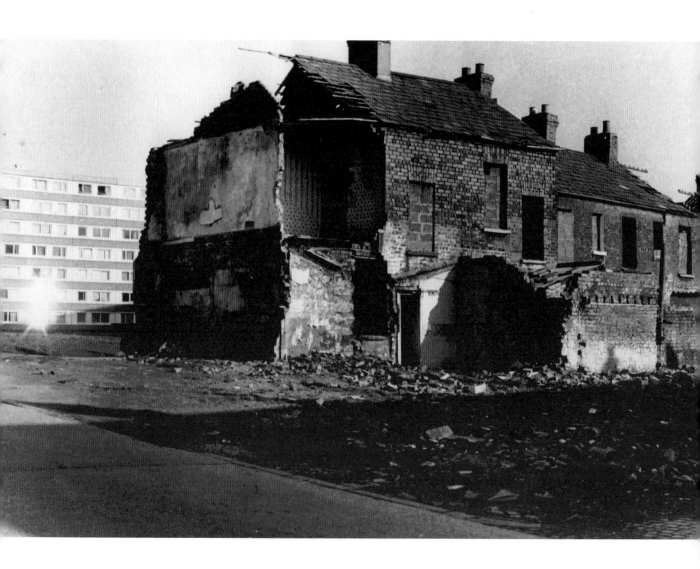

The old and new: the remains of the old houses in Albert Street, with the Divis flats complex in the background. The flats were built where the streets of the Pound Loney once stood.

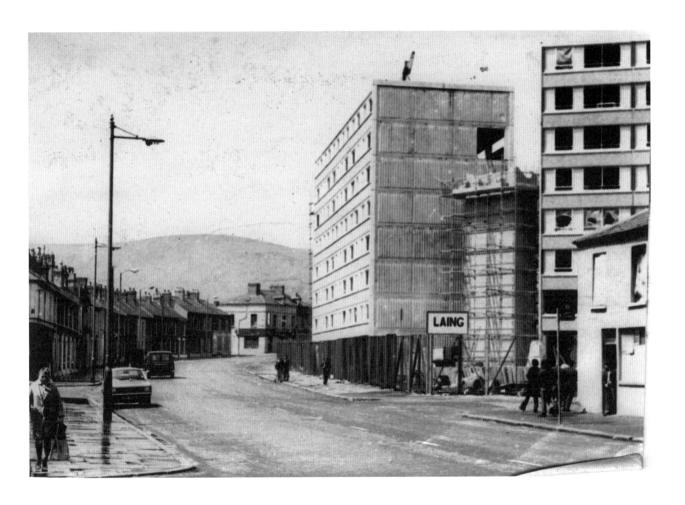

Another view of the Divis flats, this time during construction,
*c.*1968. Twenty years later, most of the complex was
demolished to make way for modern terraced housing.

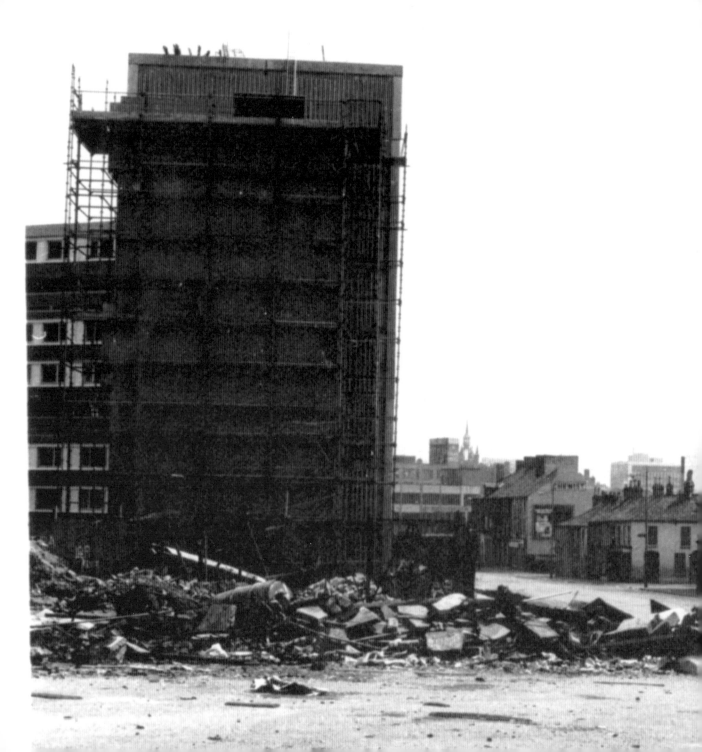

Parallel existence: on the right are the original dwellings just before demolition, while on the left the building of the Divis flats complex is progressing steadily. In the foreground, the remnants of a disused barricade are scattered across Albert Street.

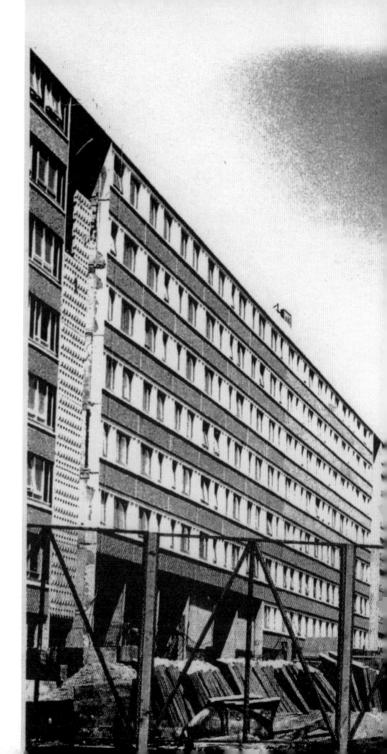

The Cullingtree Road–Albert Street junction at the time of the building of the Divis flats. Mulholland's Linen Mill chimney stands proud among the remaining old dwellings of the Pound Loney.

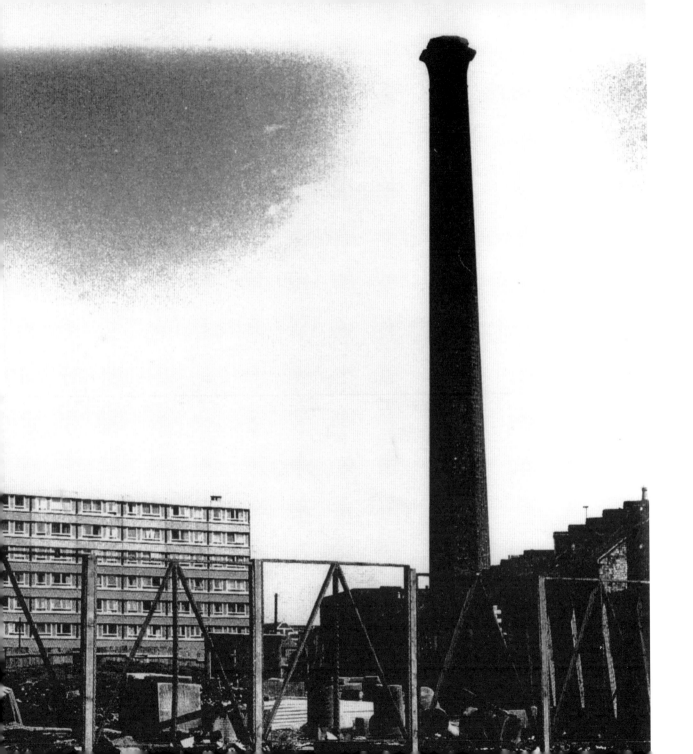

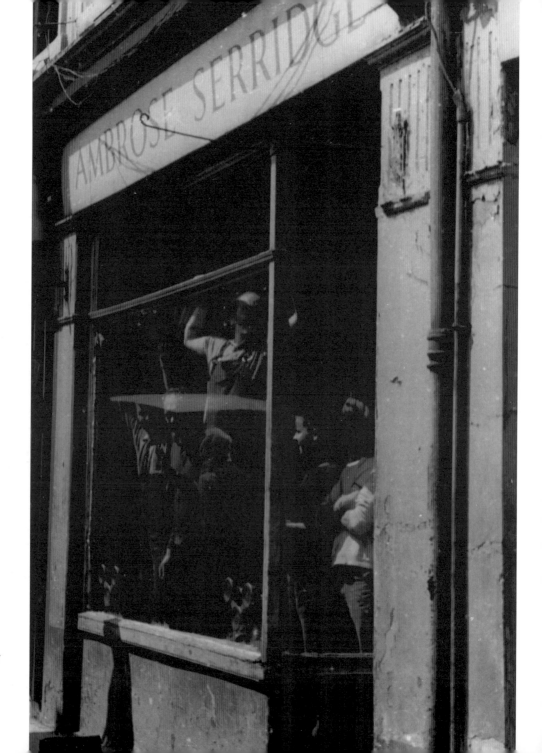

The Ambrose Serridge
bookshop at the
junction of Marquis
Street and Castle
Street, which was badly
damaged in the Castle
Street bomb in 1970.

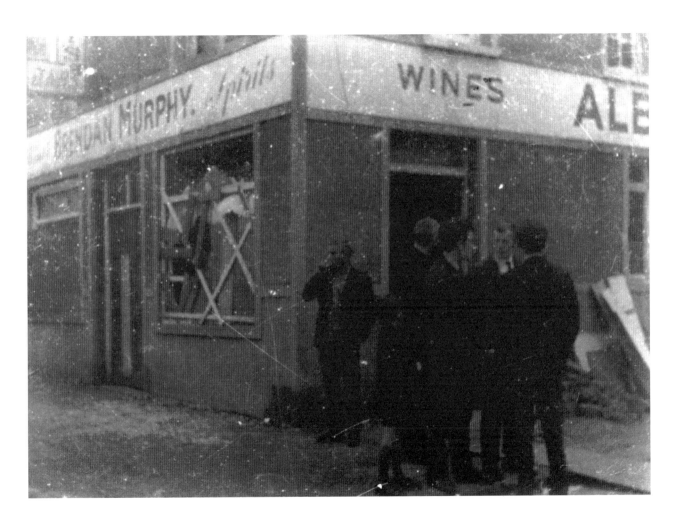

Murphy's Pub, owned by *Irish News* photographer
Brendan Murphy, in the aftermath of a bombing
in the 1970s. The pub was at the junction of
Albert Place and Albert Street.

British Army foot patrols came to the Falls in 1969. This patrol was on Slate Street: St Joseph's Primary School is on the left, and there is an old gas lamp in the centre of the photograph. This was one of the earliest foot patrols in Belfast.

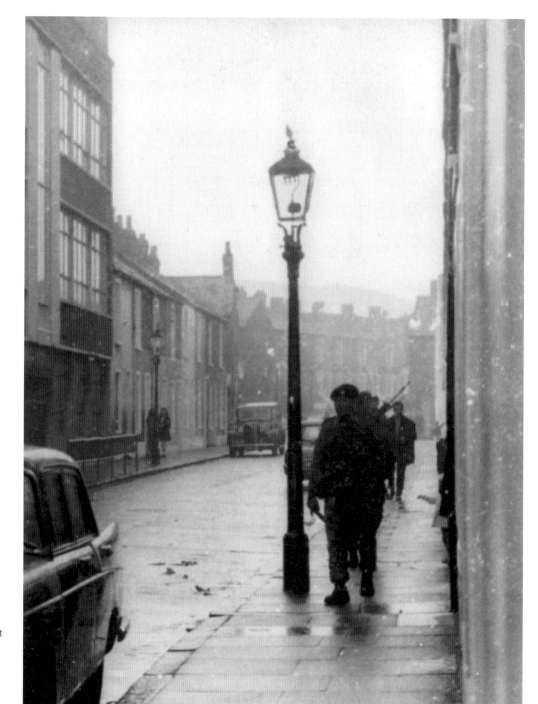

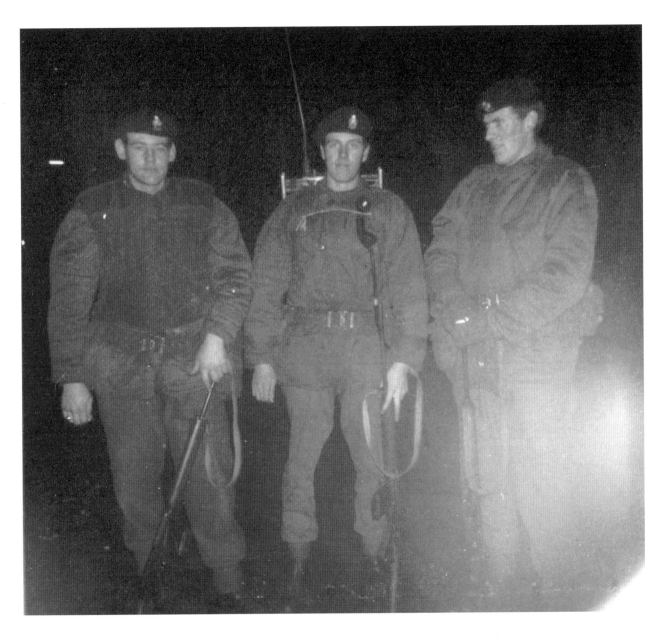

Members of a night-time army foot patrol at the barricade at the
junction of the Cullingtree and Grosvenor Roads

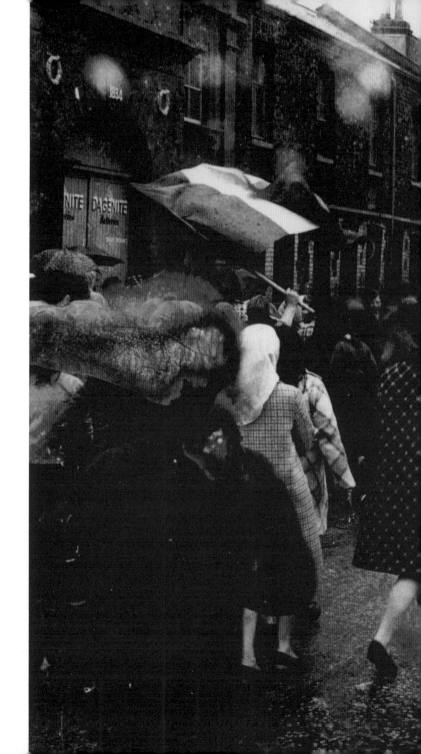

On 9 August 1971, internment was introduced in Northern Ireland. Hundreds of people were arrested and taken to British army camps. In an effort to get the men from the Falls areas released, the women went on a protest march against internment. Here they are gathering outside the temporary army billet in Albert Street, where the soldiers and Saracen tanks blocked their route. Internment lasted until 5 December 1975.

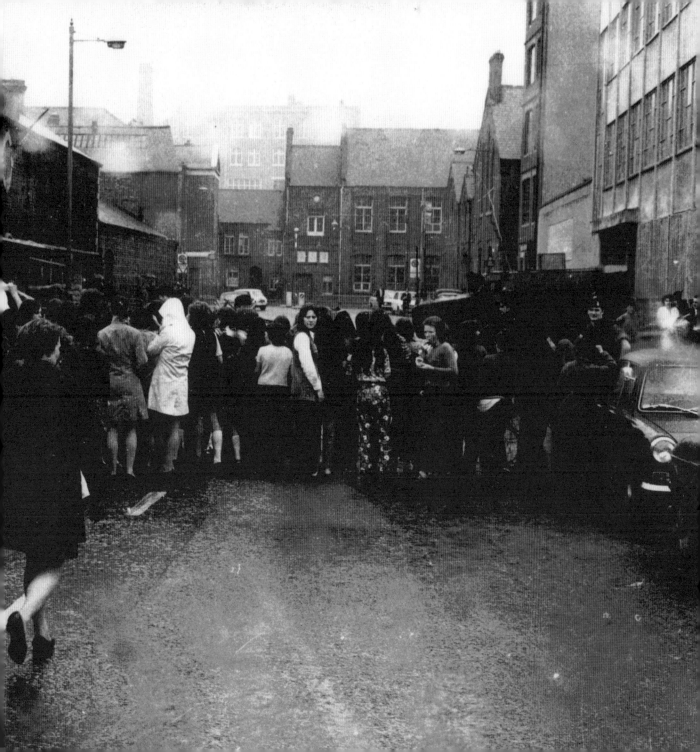

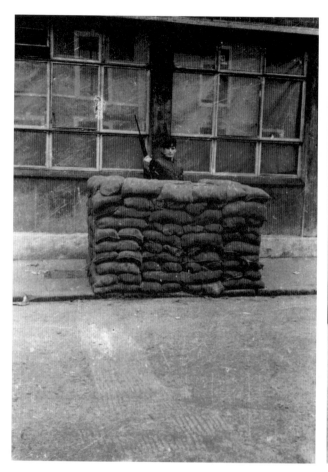

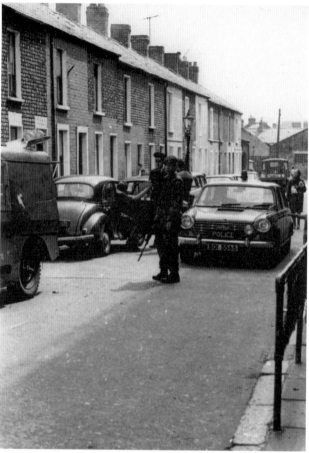

The army used Slate Street school as a temporary billet; and set up a sandbagged sentry post close to the school entrance.

The British army military police arrive to secure the makeshift billet at Slate Street school, while, in the background, a woman makes her way back from the local shops.

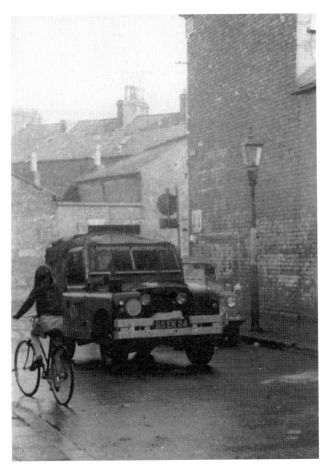

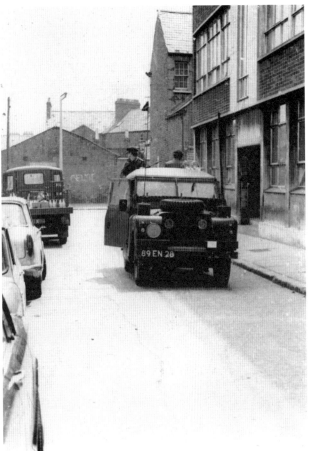

A young girl on her bike passes an army vehicle at
the lower end of Slate Street.

Another Slate Street patrol, with two soldiers
keeping watch from the back of the vehicle

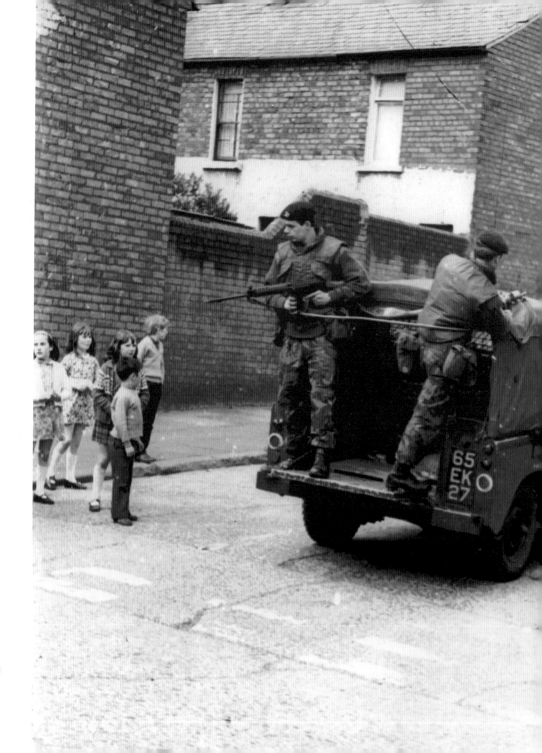

Children stop playing in
the street and patiently
wait until an army patrol
passes by.

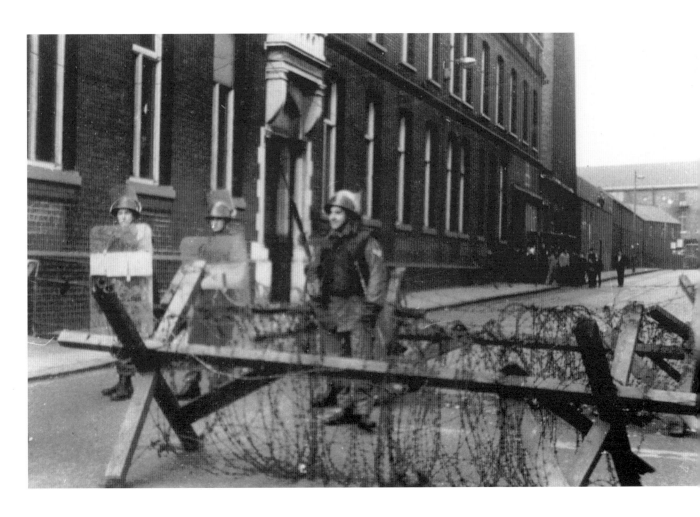

An army roadblock on Northumberland Street, with a group of workers from the local mill looking on from behind. Northumberland Street runs from the nationalist Falls Road to the loyalist Shankill. The soldiers are facing into Albert Street, the nationalist area.

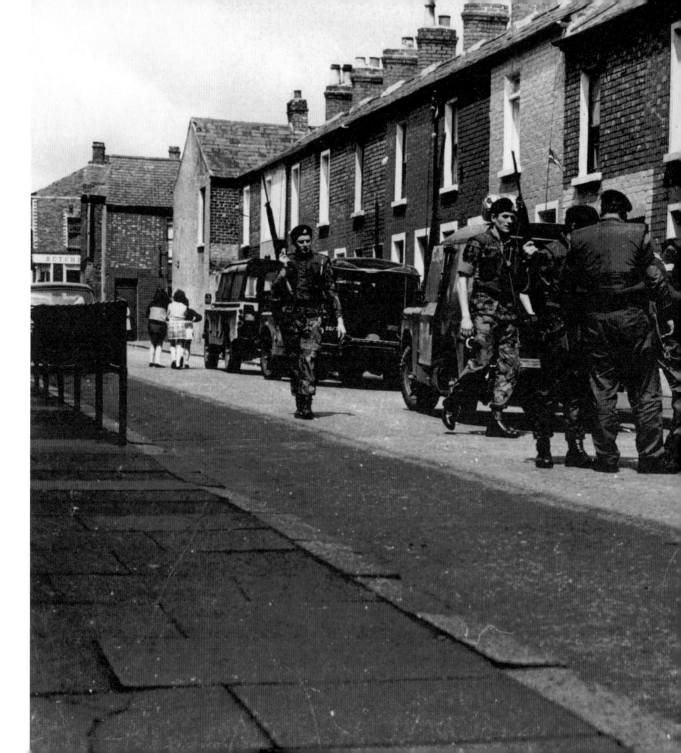

An army bomb squad checks out a stolen car, looking for a bomb in Slate Street. The adults and children in the background are still going about their normal business, unaware of the possible danger.

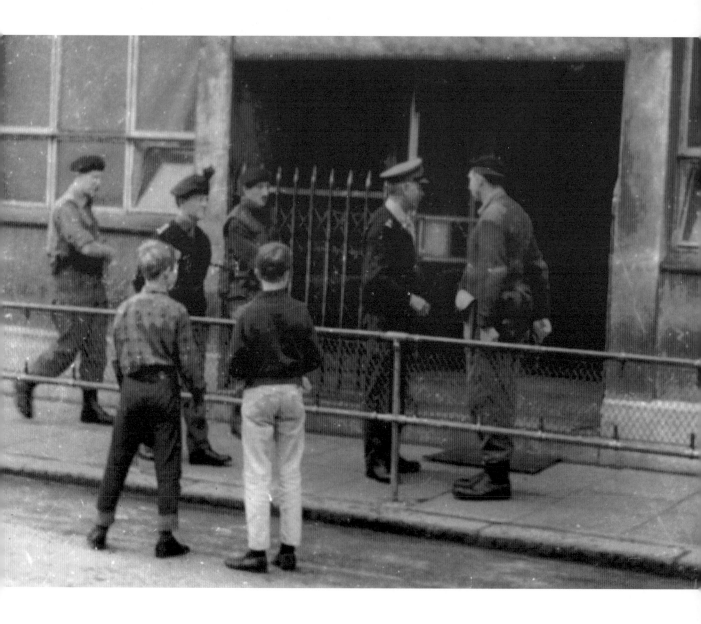

General Officer Commanding (GOC) Sir Ian Freeland visits
the Queen's Regiment, installed in St Joseph's Primary School
in Slate Street, 1971.

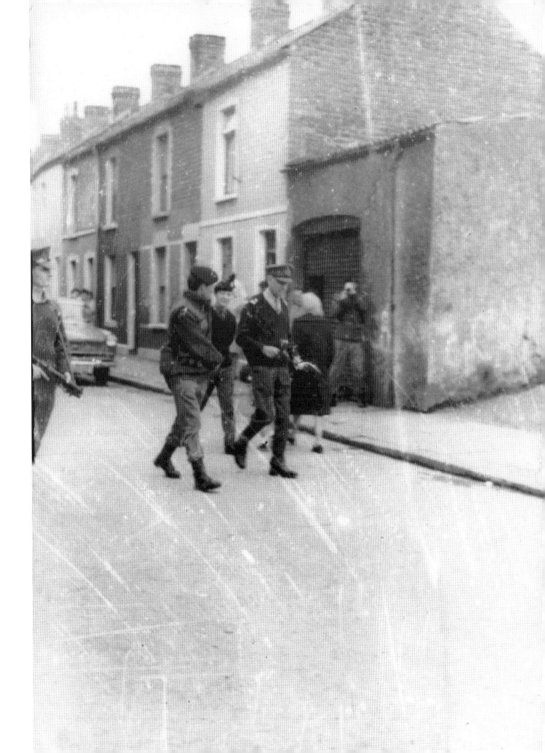

GOC Sir Ian Freeland is escorted to his car by his armed escort, cameraman and entourage. The army photographer, beside the shuttered door on the right of the picture, is photographing me photographing the General.

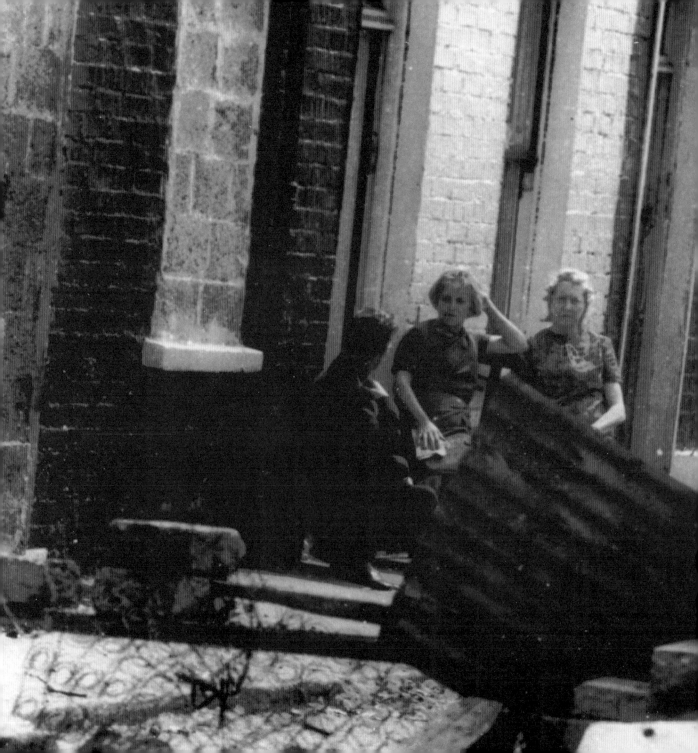

Life behind the barricades: two ladies enjoy the sun as they catch up with all the local gossip.

Being on duty behind the barricades for hours led to boredom, so these two pranksters thought it would be a good idea to play their childhood game of Cops and Robbers in and out of the old, partly demolished houses in Marchioness Street. In the dim light of the night sky, their hurling sticks looked like real firearms. The scene of moving shadows was very impressive until the powerful flash from my camera spoilt the illusion for Owen Runnigan (left) and Peter Dempsey (right). Peter Dempsey's favourite song was 'The Butcher Boy' and he sang it every night on the barricades.

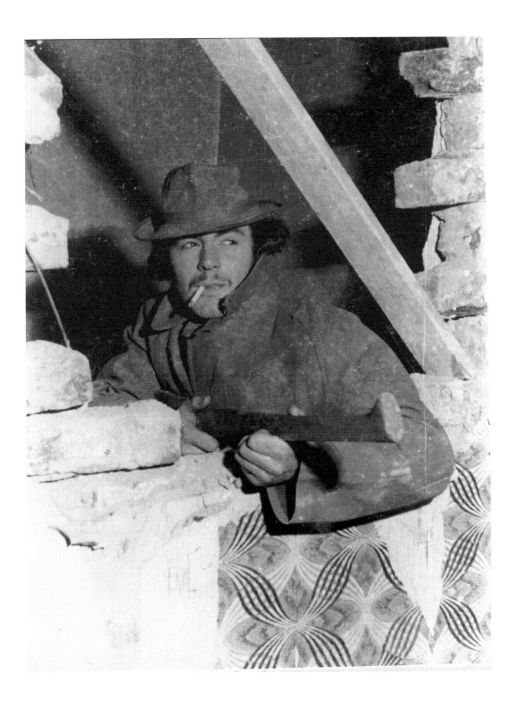

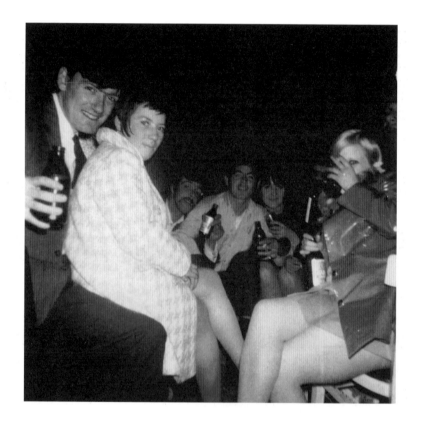

The Falls curfew began on a Friday afternoon, 3 July 1970, after the British Army raided houses in Balkan Street. As they went about destroying property and breaking down doors, they suddenly found themselves hemmed in by rioters and the solders decided to use CS Gas. The army imposed a curfew which lasted for thirty-six hours. Four people were killed. Within a day or two, food was running out for the families in the curfew areas. When the news spread about the Falls curfew, more than a thousand women from other nationalist areas of Belfast marched to the Falls with food, tea and milk. They broke through the army lines to help the confined people: the British soldiers were stood down and the curfew was over.

Any excuse for a party: many young people gathered in Marchioness Street and McDonnell Street during the curfew to enjoy the street party and watch the impromptu show of dancers, singers and musicians. The party went on till dawn the next day.

Young people from Marchioness Street bring out their own tables and chairs to enjoy the street party.

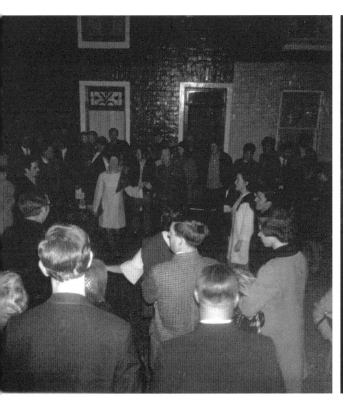

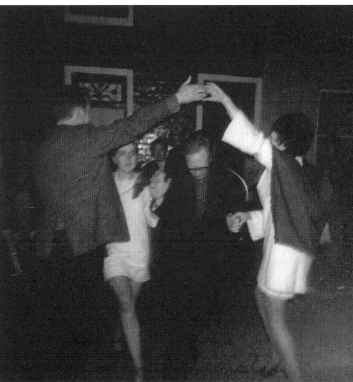

All the young men form a circle to get a closer look at the traditional dancers in the hope that they will get to dance with some of the girls.

Jim Sullivan, chairman of the Belfast Citizens' Defence Committee, joins in the fun as he dances through a guard of honour formed by the uniformed traditional dancers in McDonnell Street.

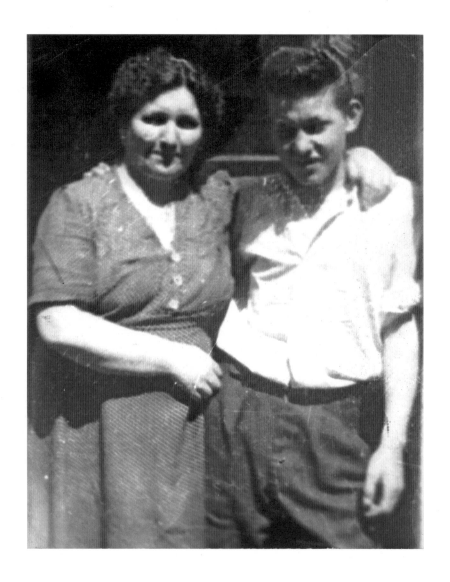

Vincent Dargan with his mother Kathleen at 44 Slate Street